(1997)

REVEALING THE
HOLY LAND

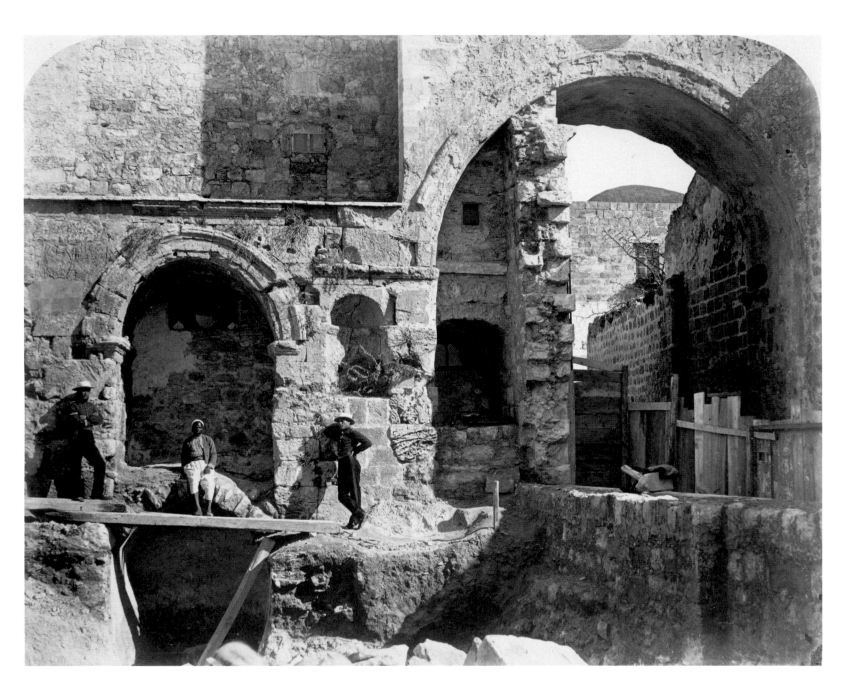

SERGEANT JAMES McDONALD
ENGLISH (1822–1885)
ECCE HOMO ARCH, 1864
FROM *PHOTOGRAPHS OF JERUSALEM*
ALBUMEN PRINT, 7 5/8 x 9 3/4 INCHES
MICHAEL AND JANE WILSON COLLECTION

REVEALING THE HOLY LAND

THE PHOTOGRAPHIC EXPLORATION OF PALESTINE

ESSAY BY KATHLEEN STEWART HOWE

SANTA BARBARA MUSEUM OF ART
1997

Santa Barbara Museum of Art
1130 State Street
Santa Barbara, CA 93101

Distributed by the University of California Press
Berkeley Los Angeles London

Editor: Patricia Ruth

Designer: Karen Bowers, Curatorial Assistance, Inc.

Index: Indexing Partners

Publication Manager: Cathy Pollock

Printer: Haagen Printing

Photographers: Scott McClaine, all photographs except:

Canadian Centre for Architecture, Montreal, p. 25
Curatorial Assistance, Los Angeles, pp. 6, 17
Robert D. Rubic, p. 29
Harry Ransom Humanities Research Center, pp. 38, 49
Zimmerman Library, p. 48

Front cover:
Sergeant James McDonald, *Plain of Er Ráhah from the Cleft on Rás Sufsáfeh.*

Back cover:
Gustave de Beaucorps, *Arab Man in Profile.*

This page:
Sergeant James McDonald, *Damascus Gate.*

Contents page:
Maxime Du Camp, *Jerusalem, Mosque of Omar.*

Library of Congress Cataloging-in-Publication Data

Howe, Kathleen Stewart.
 Revealing the Holy Land : the photographic exploration of
Palestine / essay by Kathleen Stewart Howe,
 p. cm.
 Includes bibliographical references (p. 139) and index.
 ISBN 0-89951-094-9 (hardcover). — ISBN 0-89951-095-7 (softcover)
 1. Photography—Palestine—History—19th century. I. Title.
TR113.I75H68 1997
779'.995694—dc21
 97-11157
 CIP

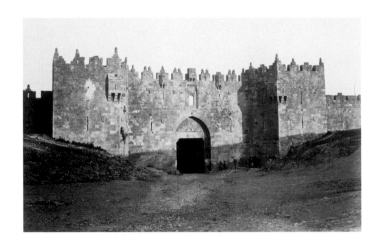

*Revealing the Holy Land
Exhibition Itinerary*

*Santa Barbara Museum of Art
January 29–May 31, 1998*

*University of New Mexico Art Museum
October 13–December 13, 1998*

*St. Louis Art Museum
February 23–May 23, 1999*

Michael Wilson introduced me to Sergeant McDonald on a summer afternoon four years ago. (Two photographs by McDonald were included in the 1994 exhibition *Travelers in an Antique Land: Early Travel Photography in Egypt,* Santa Barbara Museum of Art). I was hooked. For that introduction, and their unfailing enthusiasm, generosity, and many pleasant hours spent discussing Palestine and the Sergeant, I thank Michael and Jane Wilson. Tracing the little-known Sergeant McDonald led me to a great number of helpful people and institutions, and I thank all of them: The curators and librarians at the Royal Engineers Barracks at Brompton, where General Gordon astride his camel faces forever toward Khartoum; Drs. Rupert Chapman III and Shimon Gibson of the Palestine Exploration Fund; Violet Hamilton, curator of the Wilson Collection, and Carla Williams, the U.S. liaison for the collection; David Harris, Canadian Centre for Architecture; Andrew Brettell, Lily Koltun, and Joan Schwartz of the National Archives of Canada; George Hobart at the Library of Congress; and Gordon Baldwin, Department of Photographs, The J. Paul Getty Museum.

As always, it has been a pleasure to work with the staff of the Santa Barbara Museum of Art. I would especially like to thank fellow McDonald enthusiast and co-curator Karen Sinsheimer; Cathy Pollock, the calmest publications manager I've ever met; and editor Patricia Ruth. My colleagues at the University of New Mexico Art Museum suffered through my frequent attention lapses, and I wish to thank them for helping out with so many of my daily duties, especially Assistant Curator for Prints and Photographs, Floramae Cates. This publication owes a great deal, as does everything I do, to my husband, Jerry Burstein.

Kathleen Stewart Howe
Curator of Prints and Photographs, University of New Mexico Art Museum

To work with co-curator Kathleen Stewart Howe, a woman of intellect, wit, candor and general collegiality, was a privilege. One could wish for no better collaborator. The ongoing advice and expertise of Professor Steven Humphries, chair of Islamic studies at UCSB, also proved invaluable. Stephanie Fay and the University of California Press were a pleasure to work with, and I am grateful for their involvement.

Curatorial Assistance, Inc., once again, more than met expectations; many thanks to Graham Howe, and to Karen Bowers for her book design. Curator of the Wilson Collection, Violet Hamilton, provided essential help, as did Carla Williams. Thanks also to Louise Desy, at the Canadian Centre for Architecture; Julia van Haaften, New York Public Library; Roy Flukinger, University of Texas, Austin; and Louis Hieb, Special Collections, University of New Mexico Library in Albuquerque; photographer Scott McClaine; as well as all lenders to the exhibition.

Director Robert Frankel was supportive of the project from the moment he came on board at the Museum, and Trustee Eric Skipsey gave countless hours of volunteer support. My heartfelt thanks to the Museum staff members who were integral to the success of this publication: Assistant Curator Barbara Vilander; Publications Manager Cathy Pollock; Dodie Amenta, Lindy Zimmerman, and David Ward, curatorial support staff; Associate Registrar Lauren Silverson; and Marketing Manager Catherine Malone.

Karen Sinsheimer
Curator of Photography, Santa Barbara Museum of Art

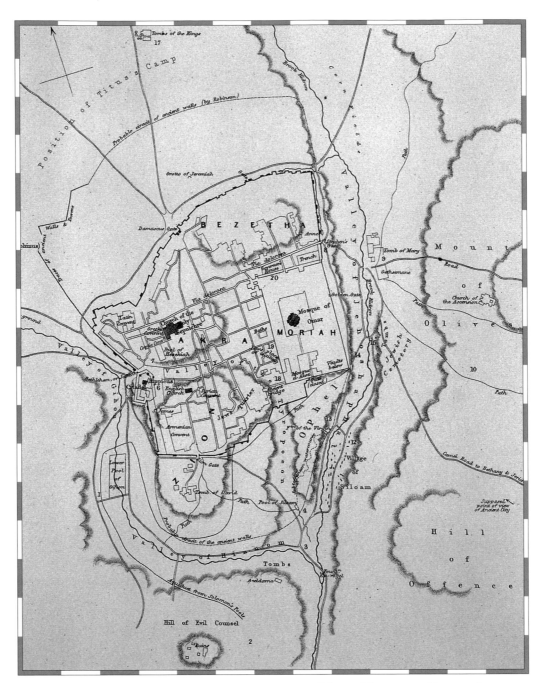

MAP OF NINETEENTH-CENTURY JERUSALEM

I*f I forget thee, O Jerusalem,*

Let my right hand forget her cunning.

Let my tongue cleave to the roof of my mouth,

If I remember thee not:

If I set not Jerusalem

Above my chief joy!

Psalm 137:5-6

CONTENTS

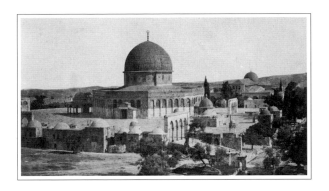

DIRECTOR'S ACKNOWLEDGMENTS

Revealing the Holy Land: The Photographic Exploration of Palestine is the second in a series of six planned exhibitions of 19th-century photographs. The first of these, *Travelers in an Antique Land: Early Travel Photography in Egypt,* undertaken in 1994, examined photographic images which chronicled the mystery—and 19th-century rediscovery—of the ancient land of Egypt. It, too, was accompanied by a catalogue, *Excursions Along the Nile: The Photographic Discovery of Ancient Egypt.*

The impetus for and the realization of this ambitious series derive from one extraordinary source: the Michael and Jane Wilson Collection. As collector, connoisseur, and contributor to the literature, Michael Wilson has made it possible to organize exhibitions of excellent quality and to exhibit works never or rarely shown. Mr. Wilson has not only undertaken careful selection and searches for material, he has also assumed the responsibility of thoughtful stewardship of his collection. Going far beyond simply caring for the photographs as art objects, with proper storage, preservation, and cataloguing, the Wilsons continually make their collection accessible to scholars, curators, collectors—both new and seasoned—and interested art groups. Significantly, Michael Wilson is deeply committed to understanding the images and the medium itself, as well as to furthering knowledge in the field. Through his own research and his support of the scholarly efforts of others, he has made important contributions to the ever-growing literature on 19th-century photography. His collection reflects passion rather than possession, and the ongoing discovery continues with *Revealing the Holy Land.*

The Santa Barbara Museum of Art owes an immense debt of gratitude to Michael and Jane Wilson as they continue to build and share their remarkable collection. Great appreciation is due as well to The Ralph M. Parsons Foundation and Christine Sisley for their very generous grant which made this publication possible. As first-time recipients, we certainly hope to prove worthy of their faith and support. I would also like to thank Karen Sinsheimer, Curator of Photography, for her unflagging energy and expertise in organizing this comprehensive series of traveling exhibitions which illuminate the 19th-century world in a way that only photography can.

Robert H. Frankel
Director, Santa Barbara Museum of Art

FOREWORD

Drawn mostly from the world-class collection of Michael and Jane Wilson, *Revealing the Holy Land: The Photographic Exploration of Palestine* offers a glimpse of rarely seen material of historical and cultural importance. These remarkable images are also compelling in themselves—often mysterious, sometimes beautiful.

Photographers journeyed to Jerusalem to capture permanent likenesses of that ancient and holy city almost from the moment an image could be fixed. The earliest photograph included here is of the Temple of Jupiter, taken around 1843 by Girault de Prangey, one of several daguerreotypists who ventured to the Holy Land. In this book, however, the principal focus is upon the three decades from 1850 to 1880. During that intense period, several foreign photographers shone their individual spotlights on Palestine. Each brought to the task his own cultural values, and each revealed and explored aspects that, woven together, compose a rich tapestry.

The core images are those by Sergeant James McDonald, who accompanied the Royal Engineers on their 1864 and 1868 surveys of Jerusalem and the Sinai. His hundreds of photographs, taken during "spare moments," provide a foundation for other foreigners' works, because McDonald's images were intended neither for commercial markets nor scholarly concerns, nor were they religiously motivated. His sole mandate for the Jerusalem survey was to capture "the most interesting places in and about Jerusalem." His photographs for the 1868 survey of the Sinai were thus essential topographic records made with the primary goal of mapping the territory; one concludes they recorded the "facts" as accurately as humanly possible.

McDonald's images were produced in album form. Single copies and stereos were later sold for commercial purposes by the Royal Engineers's office, but they have never before been exhibited and were rarely published in significant numbers. Nevertheless, as Kathleen Stewart Howe notes in her essay, they embody and illustrate "the imperial, cultural, and intellectual assumptions that England made about Palestine in the nineteenth century."

Other photographers featured here complement McDonald's perceptions. Maxime Du Camp, on his Middle Eastern sojourn in the company of Flaubert in 1850, produced a few beautiful salt prints of the region. Auguste Salzmann, who spent four months in the Holy Land, determinedly documented archaeological remnants, primarily architectural, also rendering his studies in elegant salt prints.

Amateurs Ernest Benecke and the Reverend George Bridges produced early views in 1852, the former for travel memories and the latter for personal and religious purposes. Louis De Clercq documented the ancient crusader castles at the behest of a patron, but also independently undertook a photographic record of the Stations of the Cross.

Commercial photographers flourished in the Holy Land from the early 1860s. Francis Bedford, traveling with the Prince of Wales' party in 1862, and entrepreneur Francis Frith, who established a publishing house for the production of saleable views, both produced highly popular photographs and commissioned other makers, such as Frank Mason Good, to document the Holy Land for an eager public.

These early photographs, which brought to Western Europe the first views of this sacred land, stimulated travel and pilgrimages. As tourism developed and flourished, local enterprises arose to supply the new market with views of biblical sites, complete with scriptural references, and with images of native peoples, including portraits of Middle Eastern "types." Felix Bonfils had a thriving studio producing just such imagery.

Through these pictures, taken over a period of three decades and featuring the little-known expeditionary works of master photographer James McDonald, the Holy Land of the late nineteenth century is revealed here as a complex, even mysterious, region. The images themselves—haunting, subtle in some cases, severe in others—enable us, a century later, to relive the revelations of this fascinating land.

Karen Sinsheimer
Curator of Photography, Santa Barbara Museum of Art

PALESTINE AND THE NINETEENTH CENTURY

As historic landscape, Palestine is full of those suggestive sites, those eloquent battle-fields and homes of kings and prophets, which do not need the help of mere beauty to give them interest.

THOMAS G. APPLETON, 1877

NITZA ROSOVSKY

Palestine, at the dawn of the nineteenth century, was a neglected province in the crumbling Ottoman Empire. Under Turkish rule since 1517, the country had become extremely poor. Its roads were no more than dirt paths; commerce barely existed. Roaming bands of Bedouin robbed and terrorized the inhabitants. Corruption was rampant throughout the empire, and the ruling pashas, having obtained their own positions through increasingly exorbitant bribes to the officials of the Sublime Porte in Constantinople, in turn increased their taxation of the local population. These high taxes, along with poverty, disease, and the lack of security, depleted the number of inhabitants in both the countryside and the cities. By 1800, when London's population reached one million and Tokyo's a million and a half, Jerusalem's was a mere nine thousand.

The whole population of Palestine was only three hundred thousand. The majority were Muslims, most of whom lived in villages; ten percent were Christians, mostly Greek Orthodox and Latin Catholics, with some Armenians and members of other small sects. European Jews began to return to the country in 1777, joining the small Sephardi community already there. By the turn of the nineteenth century, the Jewish population, numbering three thousand, lived principally in the "Four Holy Cities," Jerusalem, Hebron, Safed, and Tiberias. Unprepared for the hardships in the country, unable to find employment, and prevented from owning land, the European Jews lived in poverty, surviving on *halukah*, money sent by their brethren abroad.

Daily life at the beginning of the century was dismal. In the cities open sewers ran through unpaved, garbage-strewn streets. There was no running water; in the villages women still drew water from

wells and carried it home in jars balanced on their heads, as they had in biblical times. Rainwater was collected in cisterns, which were usually dry by summer. Water could also be purchased from carriers who brought it in goatskins from springs and pools. Bread was baked at home in primitive outdoor ovens from flour milled by hand. There were no doctors in the country until 1838, and epidemics were rife. There were no streetlights, and citizens were required by law to carry lanterns; any person caught without one was taken for a thief. The gates of walled cities were locked from sundown to sunrise for protection. Social life in the villages centered on the common well; in the cities it revolved around coffeehouses and *hamams* (bathhouses). Religious holidays provided diversion from daily toil, as did the weekly market day.

After centuries of post-Crusade indifference, European interest in the Near East began to grow again, following the 1798 invasion of Egypt by Napoleon. The Ottoman Empire, often referred to as "the sick man on the Bosporus," continued to decline throughout the nineteenth century. Nationalism in the countries subjected to Ottoman rule, along with tensions between reformists and conservatives in Constantinople itself, tore at the weakening fabric of the empire. The Western powers, although they had their own designs on lands controlled by Constantinople, did not want to see it collapse completely because they feared Russian expansion. Thus they came to the sultan's rescue on several occasions—during the Napoleoic invasion; later, when Egypt's Muhammed Ali rebelled in 1831; in the course of the Crimean War (1853–1856)—thereby gaining a foothold in the Holy Land. Under obligation to the West for its help, the Ottomans were forced to issue a number of extraterritorial privileges, the so-called Capitulations. First they recognized all existing religions, as well as equality before the law and individual liberty. Later, European residents of the empire were granted almost complete legal immunity, placing them under the protection of the consular representatives of their own countries. The Capitulations bettered the lives of the different minorities, especially Christians and Jews, throughout the empire.

Palestine experienced many changes under Egyptian occupation—a result of Muhammed Ali's rebellion in 1831. For nine years the country was governed by Ibrahim Pasha, Ali's adopted son, who instituted many reforms: he paid local pashas official salaries so that they no longer had to bribe their way into office; he collected taxes on a regular basis; he granted permission to repair churches and synagogues; and he allowed foreign powers to open consulates in Jerusalem. Even when the Ottomans reconquered Palestine, privileges and reforms could not be readily withdrawn. In 1845 the first Protestant church in the Ottoman Empire was consecrated in Jerusalem, and the quality of life in the Holy Land gradually improved under the growing influence of foreign representatives of both church and state.

The West's new focus on the area, and especially the Holy Land, went beyond military and political interest. Large segments of the Protestant world at the turn of the century believed that the millennium was at hand. Because the return of the Jews to the land of their ancestors and their conversion

were seen as necessary preludes to the Second Coming, missionary societies were formed in England and the United States early in the nineteenth century to convert the Jews. Other forces at hand during that period—a shift from the rational philosophies of the Enlightenment and a reaction against scientific discoveries, particularly the new theories about creation—changed popular attitudes toward religion. A yearning to return to a simple belief in God was accompanied by the desire to re-examine the scene of biblical events. The Industrial Revolution had created a new class with both the means and the leisure to travel, and many undertook this new extension of the Grand Tour. Travel conditions improved when steam replaced the sail, and soon the Holy Land was swamped by pilgrims and tourists. Missionaries and clerics came, as well as soldiers and diplomats, adventurers, explorers, writers, painters, and, by 1839, photographers.

It was the missionaries who first brought profound changes to the country's landscape, economy, and social structure, yet their lot was not easy. The first two, Levi Parsons and Pliny Fisk, were sent to the East in 1820 by the American Board of Commissioners for Foreign Missions. Parsons fell ill after a brief stay in Jerusalem and died in 1822; Fisk died three years later of infected wounds. But the problems the Protestants experienced were not only physical. In the Holy Land they were met by a hostile Jewish community, similarly unwelcoming local Christians, and suspicious Muslim authorities. Despite tremendous efforts and expense—about one thousand pounds sterling were spent per convert—very few Jews succumbed to proselytization. Since Muslims were forbidden by law to convert under threat of death, the Protestants were most successful when re-baptizing other Christians, a practice which infuriated the local churches.

In the 1830s, the London Society for the Promotion of Christianity amongst the Jews sent the Reverend John Nicolayson to Jerusalem, and shortly thereafter Lutheran Prussia joined the Anglicans to establish a united bishopric. (Ironically, the first bishop to Jerusalem was a converted Jew, Michael Solomon Alexander.) The churches' competition for power and influence brought to Jerusalem, in addition to the Protestant bishop, a Greek Orthodox patriarch, a Latin patriarch, and a Russian archimandrite. The Protestants established a clinic and pharmacy, followed by a hospital, several schools, and other charitable institutions. The Jewish community, fearing that some among them might be lured away by Christianity—which offered access to the only doctors in town—hastened to build its own hospitals and schools, with help from philanthropist Sir Moses Montefiore and the Rothschild family. All the major Christian denominations followed suit. The resultant building activity changed the cityscape of Jerusalem and provided much-needed opportunities for employment. Rival European diplomatic representatives, anxious to broaden their influence in the area, not only supported missionary activities but also extended their protection over the different Christian natives. Thus Russia took the Greek Orthodox community under its wing, while France supported the Catholics. Late comers on the scene, the Protestants had no co-religionists there, so England offered its protection to the Jewish community.

Further improvements came with the opening in 1869 of the Suez Canal, which brought the country close to one of the most important trade routes in the world. Foreign goods flooded the markets of Palestine, while local agricultural produce, which had improved dramatically, was shipped abroad, mainly through the ports of Jaffa and Haifa. In 1892 the first railway connected Jaffa and Jerusalem to the rest of the Ottoman Empire.

Much of our knowledge of life in Palestine during the nineteenth century comes from the descriptions of long- and short-term visitors who recorded their impressions in letters, journals, diaries, paintings and photographs, and in enormously popular travel books. In the United States, for example, the Reverend William M. Thomson's *The Land and the Book* (1859) sold two hundred thousand copies, and Mark Twain's *The Innocents Abroad* (1869) outsold the author's other books during his lifetime.

With the exception of those so elated merely by "walking in the footsteps of Jesus" that they closed their eyes to the prevailing poverty, dirt, and disease, most travelers to Palestine were disillusioned. Reality did not match their childhood images of the Land of the Bible. Mark Twain expressed it best: "The word 'Palestine' always brought to my mind a vague suggestion of a country as large as the United States . . . I suppose it was because I could not conceive of a small country having so large a history." Protestants, affronted by the highly ornate churches, found the bigotry and hatred which existed among the various Christian denominations even more offensive. John Lloyd Stephen was the first American to write a book about the Holy Land, *Incidents of Travel,* after an 1836 visit. He found the Church of the Holy Sepulchre to be "full of tawdriness and bad painting, redolent of vulgar superstition." Others called it the "pretended sepulchre," or "the least sacred place in Jerusalem." It was common for Christians to consider as punishment the desolation of the land where milk and honey once flowed. William Makepeace Thackeray saw the landscape as "unspeakably ghastly," and thought it "quite adapted to the events which are recorded in the Hebrew histories. . . . In the centre of this history of crime rises up the Great Murder of all." Upon leaving the country Twain wrote: "Palestine is desolate and unlovely, And why should it be otherwise? Can the curse of the Deity beautify a land?"

However, most serious scholars who got to know the land better—unlike the typical traveler who often spent less than a week there—discovered a measure of beauty in the traces of past grandeur. "Jerusalem is one of the few places of which the first impression is not the best," said Arthur P. Stanley, dean of Westminster and author of *Sinai and Palestine* (1856). Artists, too, appreciated the special qualities of the Holy Land. Many of the books about the country published during the nineteenth century were enhanced by illustrations, mostly done by skilled amateurs. But a number of professional painters—David Roberts, William Holman Hunt, James Tissot—worked in Palestine as well, perhaps no longer satisfied with the religious imagery inspired by Renaissance art. Less cerebral than their literary counterparts, they

celebrated in their works their own responses to the sensuous beauty of the land—the brilliant colors and bright sunshine, the exotic bazaars and romantic ruins.

Although many of the artists complained bitterly in letters and journals about conditions in the country, they did not reflect that harsh reality in their works. This was especially true of the photographers, even though the two men who ushered photography into the world in 1839, Louis Jacques Mandé Daguerre and William Henry Fox Talbot, saw the medium as an accurate portrayer of nature. A photograph is "a chemical and physical process which gives Nature the ability to reproduce itself," said Daguerre. "How charming it would be if it were possible to cause . . . natural images to imprint themselves durably, and remain fixed on the paper," mused Talbot. And of Palestine itself the Reverend Albert Augustus Isaacs declared in *The Dead Sea* (1857): "We know how often the pencil is proved to be treacherous and deceptive, while . . . the fac simile of the scene must be given by the aid of the photograph." Yet just like painters, photographers selected and "edited" the scenes they captured. The brush and lens portrayed things differently from the pen because writers could describe both the good and the bad in one book, while painters and photographers had but one shot at a scene, and depictions of dirt, poverty, or misery did not sell. Photographers also excluded from their works the exotica or erotica often encountered in Orientalism. Like the painters, they treated the "land called holy" with a certain reverence.

Photographers, even more than painters, were attracted by the crystal-clear, harsh sunlight so useful in the early days of the medium, when insensitive emulsions meant long exposure times. Interestingly, the Hebrew word for photographer in the nineteenth century was *tsayar shemesh*, and Arabic still uses the term *mussawwra*, both meaning "painter of the sun." Because the Second Commandment forebade the creation of "graven images," there were no Jewish or Muslim photographers in the country until almost the end of the century (with the exception, in the 1850s, of Mendel John Diness, a Jew converted by the Protestants, whose work was presumed lost until a decade ago).

By 1900 Palestine was on the verge of modernization. The population had nearly doubled during the previous century and passed a half million; many Jews had settled there—Orthodox Jews hoping to hasten the arrival of the Messiah by living in the Land of Israel, and secular Zionists whose creed emphasized working the land with their own hands. Muslims had come as well, from war-torn lands in the Balkans and North Africa. In Europe a new Germany arose, with its own interests in the East, and established a close relationship with Constantinople. The century that had opened with Emperor Napoleon's invasion of Egypt closed with Kaiser Wilhelm II's visit to Jerusalem in 1898. The alliance between kaiser and sultan helped hasten the demise of the Ottoman Empire, and, with the end of World War I, a new era began in the Holy Land, an era of new aspirations and new conflicts— as yet unresolved.

REVEALING THE HOLY LAND
NINETEENTH-CENTURY PHOTOGRAPHS OF PALESTINE

Our reason for turning to Palestine is that Palestine is our country.
I have used that expression before and I refuse to adopt any other.

WILLIAM THOMSON
ARCHBISHOP OF YORK ADDRESS TO THE PALESTINE EXPLORATION FUND, 1875

KATHLEEN STEWART HOWE

It was dry and dusty on the steep road between Jaffa and Jerusalem. As the road crested the last rise over the Judean Hills, Captain Charles Wilson and a small complement of Her Majesty's Royal Engineers caught their first sight of Jerusalem. It was 2 October 1865. They had landed at Jaffa just two days earlier and now paused, laden with bulky survey and photography equipment, to savor their first look at the ancient city they had come to map and measure. That first sight of Jerusalem had affected generations of travelers in dramatically different ways.[1] In 1832, future British Prime Minister Benjamin Disraeli saw a city the impact of whose appearance matched its importance to the world:

> I beheld a city entirely surrounded by an old feudal wall. In the front was a magnificent mosque, with beautiful gardens and many lights and lofty gates of triumph; a variety of domes and towers rose in all directions from the buildings of bright stone. I was thunderstruck. I saw before me apparently a gorgeous city. Except Athens, I had never witnessed any scene more essentially impressive. I will not place this spectacle below the city of Minerva. Athens and the Holy City in their glory must have been the finest representations of the Beautiful and Sublime.[2]

Yet, ten years later, the grandeur of associations could not disguise the sad state of the city from the artist W. H. Bartlett: "If the traveller can forget that he is treading on the grave of a people from whom his

In order to avoid the unnecessary distraction of [sic], quotations from period sources are presented using their original spellings and grammar.

MAP OF OTTOMAN PALESTINE

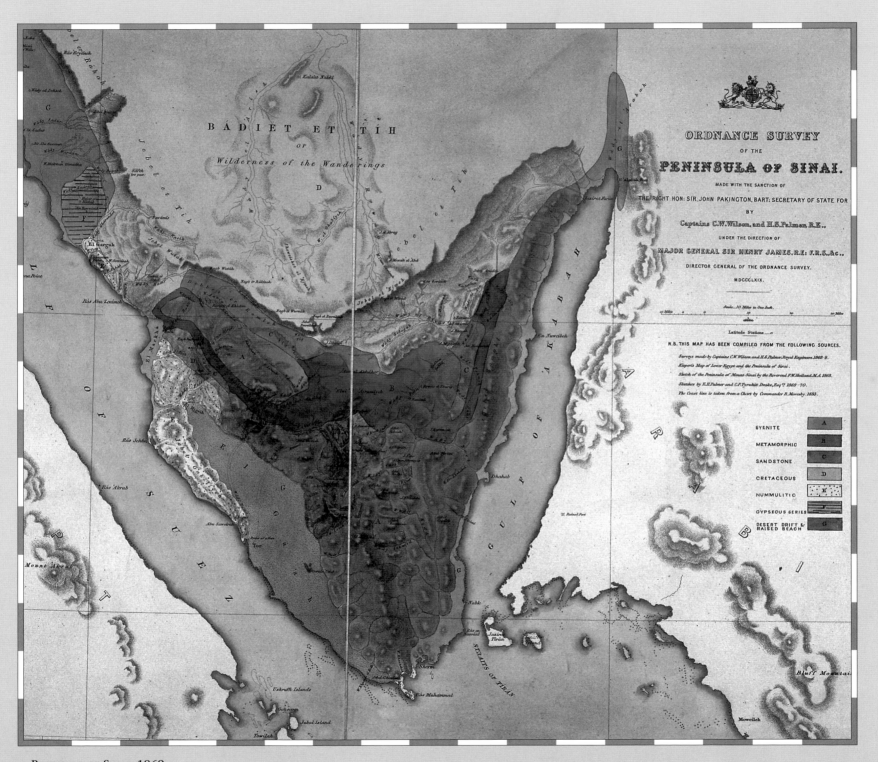

PENINSULA OF SINAI, 1869

religion has sprung, on the dust of her kings, prophets, and holy men, there is certainly no city in the world that he will sooner wish to leave than Jerusalem. Nothing can be more void of interest than her gloomy, half-ruinous streets and poverty stricken bazaars."[3]

Others, such as the novelist William Makepeace Thackeray, found that its aura precluded any inventory of physical characteristics. Jerusalem was simply too potent for description. "The feelings of almost terror with which, riding throughout the night, we approached this awful place, the center of the world's past and future history, have no need to be noted."[4]

The reactions of Captain Wilson, his sergeant, and the four noncommissioned engineers went unrecorded. They were there to make a precise survey of Jerusalem with special attention to the city's ancient water system. Although all of them were members of the Royal Engineers, their mission was a private one, funded by the wealthiest woman in England after the queen, Lady Burdett-Coutts. Wilson carried letters from Sir Moses Montefiore, recently elevated to the English peerage and one of the most influential Jewish figures in the Western world, recommending their project to the ancient Jewish community in the city. The appropriate diplomatic contacts had been made. Izzet Pasha, the Turkish governor of Jerusalem, expected their arrival; his protection and permission, or *firman,* was assured.

Despite such high-level support, this seemed a relatively small and insignificant project when compared to the Royal Engineers's surveys of England, Ireland, and India—massive projects that had established the engineers' reputation for unquestioned competence. Nevertheless, the survey undertaken by this small party and later published as the *Ordnance Survey of Jerusalem* would set in motion a chain of events that provided the impetus for the formation of a society dedicated to the scientific exploration of the Holy Land, the Palestine Exploration Fund (PEF). More military survey teams came to map Palestine under the auspices of this fund. Wilson commanded one of them three years later, a survey of the Sinai Peninsula. James McDonald, the sergeant accompanying Wilson on that dusty day on the road to Jerusalem, photographed both surveys (figure 1, p. 19).[5]

Unfortunately, McDonald's survey photographs have been eclipsed by the more commercial photographic publishing efforts of Francis Frith, Francis Bedford, and Frank Mason Good, to name the most prominent of the purveyors of biblical views, while connoisseurs of photographic art have preferred to focus almost exclusively on the early salted paper prints made by Maxime Du Camp and Auguste Salzmann.[6] Nevertheless, McDonald's photographs repay our close attention. They are strong visual statements that speak to the tangled motivations that mark the British engagement with Palestine in the nineteenth century. Palestine was a key region in British geopolitics, and, as the Holy Land, it occupied a central place in English cultural geography, conditioned by long familiarity with and recourse to the Bible. *Revealing the Holy Land* returns McDonald's survey photographs to their central position in the history of

photography in the Holy Land. Their significance will become apparent as we explore their cultural context, the circumstances of their creation, and the implications of McDonald's photographic record.

Interest in Jerusalem and the Holy Land was particularly pronounced in England, for reasons only partly pragmatic.[7] The necessity of controlling Palestine in order to protect the riches of India was a response to the exigencies of geography, but there was also the more nebulous matter of Britain's cultural identification with the people and lands of the Bible. In Britain, the study of the Holy Land moved beyond doctrinaire religious concerns to encompass issues of imperial might and historic prerogatives. In the nineteenth century, history was the governing concept that united almost all intellectual inquiries: the life of the mind was peculiarly involved in the search for origins—of species, of languages, of societies, of beliefs. History was the inevitable touchstone for these inquiries, and the Bible was the ultimate history. Thomas Huxley's admonition to "consider the great historical fact that this book has been woven into the life of all that is best and noblest in English history, that it has become the national epic of Britain," was not mere

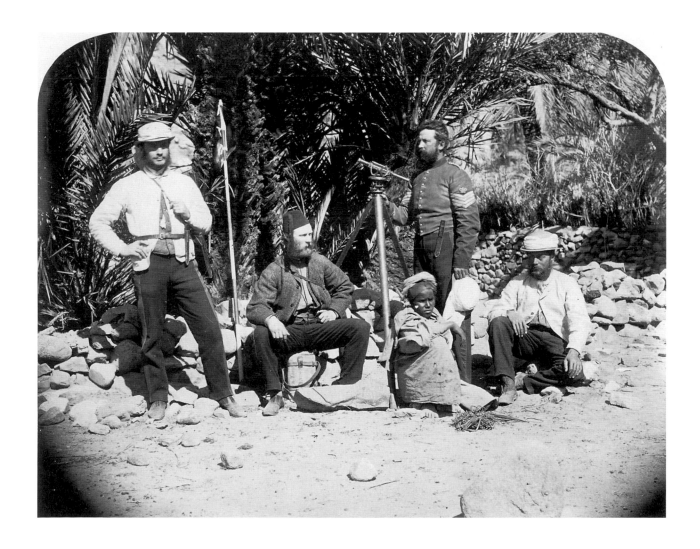

FIGURE 1

SERGEANT JAMES MCDONALD. *NONCOMMISSIONED OFFICERS OF THE ROYAL ENGINEERS*, FROM *ORDNANCE SURVEY OF THE PENINSULA OF SINAI*, 1868–1869. ALBUMEN PRINT. MICHAEL AND JANE WILSON COLLECTION.

SERGEANT MCDONALD IS SECOND FROM THE RIGHT.

religious hyperbole, coming as it did from the man who coined the term "agnostic" to describe his own religious position.[8] Huxley made his remark in defense of teaching the Bible in public schools during the great debate surrounding educational reform. He was not alone in his veneration for the Bible as a particularly British institution. From the sixteenth-century division of the English Church from Rome, through the sway of Cromwell's Puritans to the evangelical devotion of middle-class Victorians, the Bible, and especially the Old Testament, had served as a template for describing and understanding English history. In *Culture and Anarchy* (1868), Matthew Arnold linked "the genius and history of us English to the genius and history of the Hebrew people." John Ruskin, the most influential art critic of the day, declared on the first page of his autobiography that the single most valuable part of his education was his mother's insistence that he read the entire Bible aloud—"every syllable through, hard names and all"—once a year, only to begin again at Genesis when he had completed the last page.

British photographic practice in Palestine, and in particular that of Sergeant McDonald, was marked by this confluence of imperial ambition and deeply ingrained cultural associations. Sergeant McDonald's photographs from the two surveys of Jerusalem and the Sinai epitomize the paired imperatives of biblical research and empire building. The Palestine Exploration Fund, a direct outgrowth of the survey accomplished by the Royal Engineers in Jerusalem, continued the model of biblical research carried out by British military officers. These intertwined interests and motives come to fruition in the work of Colonel Claude Regnier Conder of the Royal Engineers, who led many of the PEF expeditions. At the end of his explorations, Conder was widely regarded as having contributed more to the understanding of the Bible than any man (Englishman, that is) since William Tyndale prepared the first printed English translation in 1525. Less well-known is the fact that Conder's maps, drawn in the course of PEF research expeditions and published by the Royal Ordnance Survey, played a pivotal role in General Allenby's conquest of Jerusalem in 1917. Allenby's victory over the Turks in turn triggered the British Mandate and the Balfour Declaration, which officially opened Palestine to Jewish settlement and affirmed the right of the Jewish people to settle in their ancient land.[9]

The physical reality and the psychological impact of Jerusalem and Palestine seemed dreadfully mismatched to nineteenth-century visitors. In 1839, two very different photographic processes were announced—the Frenchman Louis Jacques Mandé Daguerre demonstrated his invention, the daguerreotype, in Paris as the Englishman William Henry Fox Talbot displayed the results of his paper negative process in London. Within a few short months, the city and countryside that aroused such extremes of reaction became among the most photographed places on earth. These photographs were made during a time which had not yet lost its naïve faith in the objective truthfulness of photography. How would a place seen in so many different ways by Western travelers be interpreted by the objective lens of the camera?

Would it appear a great and glorious city—the "shining city on the hill" of hymn and verse—or a shabby, walled outpost of an obscure province of the Ottoman Empire? Nowhere was the divide between the expected and the actual greater than for photographers and their audiences. Notwithstanding these problems, throughout the last half of the nineteenth century, Jerusalem and Palestine, the Holy Land, drew photographers—amateurs recording a part of the Grand Tour, academics seeking proof for archaeological theories, professional surveyors, and commercial purveyors of views to tourists and armchair travelers. In different ways, each of these photographers tried to capture the "reality" of a land that had enormous spiritual, emotional, and political connotations for most of the Western world.

"REDISCOVERING" THE HOLY LAND

In 1799, Napoleon brought his Army of the Nile to the walls of Acre, the Palestine port where five centuries earlier the Crusaders had made their last stand in the East. Fourteen times, the French forces stormed the walls, and each time they were repulsed. A fleet of British warships in Acre's harbor aided the Turkish defenders by maintaining a steady artillery barrage on Napoleon's attacking force. Napoleon's adventure in the East was coming to an ignominious close but the rediscovery of Palestine was just beginning. Britain's presence as protector and imperial counterweight to France under Napoleon foreshadowed her nineteenth-century role in the region.

Before the Battle of Acre, Palestine was almost *terra incognita*. It existed as a spiritual geography, its borders a palimpsest of Biblical, Roman, and medieval conquests. Technically it was a poor section of the Ottoman province of Syria. Paradoxically, in the eyes of the Christian West, this desolate part of the obscure East was the glorious land of the Bible. The mighty kingdom of David and Solomon was in actuality the insignificant satrapy of an Oriental despot. The religious fervor that had inspired the Crusades had died with the last of the Crusaders's kingdoms in the East. Palestine existed for Europe as an idea, at once glorious and obscure, mighty and fallen. Traders and envoys visited, but few travelers or pilgrims subjected themselves to the arduous journey. Those who did almost invariably commented on its former prosperity as the land of milk and honey and its current state of desolation. The more religious saw in these circumstances a punishment for the crime of the Crucifixion.

Although few had visited Palestine, there was a sense of what the land and its sacred sites looked like, fostered by centuries of representations by painters, printmakers, and illustrators. Generic views of a walled city labeled "Jerusalem" appeared in some of the earliest illustrated printed books, *The Nuremburg Chronicle* (1493) and *Peregrinationes in Terram Sanctam* (1486). Later illustrations, whether based on sketches made by travelers or generated by the fertile imaginations of artists, gave a more specific visual

presence to Bible stories. Throughout the next four centuries, views of Jerusalem and the Holy Land appeared in travel accounts, biblical histories, and devotional texts.

The eighteenth century was the heyday of travel accounts. Even the sober poet and essayist Joseph Addison confessed that "there are no books which I more delight in than in travels!"[10] The demand remained high into the nineteenth century, and in the 1830s an average of forty books a year were published on travels to the Holy Land alone. Most were illustrated with views of the area, many made from travelers' on-the-spot sketches redrawn for publication by professional artists. Publishers also commissioned artists or, perhaps more accurately, skilled draughtsmen, to travel through the region and make sketches designed for reproduction in accounts of their travels. William Bartlett wrote and provided the illustrations for one of the more popular books, *Walks About the City and Environs of Jerusalem* (1843).

The Scottish artist David Roberts, recognized as one of the premier architectural and topographic artists of the time, was one of those artists drawn to the Holy Land. He was in Jerusalem on a tour through the East, during which he accumulated hundreds of sketches, including panoramas of Cairo and three whole sketchbooks of costume studies and visual details. Although he would rearrange and shuffle this raw material in his Oriental paintings for the next twenty-five years, it appeared first in finished drawings he made for lithographic reproductions. A set of six folio volumes, lavishly illustrated with 247 lithographs and published as *The Holy Land, Syria, Idumea, Arabia, Egypt and Nubia* (1842-1849)[11] was extravagantly praised as "a noble and beautiful work" and "one of the most valuable publications of our day—vividly illustrating our readings in history, sacred as well as profane."[12] The set of lithographs was immensely popular; it combined the undeniable authenticity of the artist's experience (passages from Roberts's journals appear frequently in the short texts accompanying the lithographs) with the immediacy of large, handsome lithographs (p. 48). His careful renderings of land and architecture possessed the sense of drama one would expect from a former theatrical scene painter at Drury Lane and Covent Garden, and they were satisfyingly replete with the elements of local color that photography would not be able to provide for at least a decade. These added details were in fact criticized by John Ruskin, who complained, "We have been encumbered with caftans, pipes, scimitars, and black hair, when all we wanted was a lizard or an ibis."[13] Ruskin's quibble may have been based not on aesthetic principles, but on his distaste at seeing the Turkish and Arab presence in the Holy Land literally foregrounded.

THE FIRST PHOTOGRAPHS IN THE HOLY LAND

The most successful illustrator of the Holy Land met the first photographer of the Holy Land, if only metaphorically, in Jerusalem in 1839. That year saw David Roberts making sketches in Jerusalem and Frédéric

Goupil-Fesquet anxiously peering at the silvered plate in his mercury vapor development chamber, hoping to see a miniature Jerusalem appear. Goupil-Fesquet photographed Jerusalem between 11 and 14 December 1839, a scant three months after Daguerre's process was demonstrated in Paris. And another photographer, Pierre-Gustave Joly de Lotbinière, was right behind him. (Goupil-Fesquet and the painter Horace Vernet had in fact met the young man aboard the steamer *Ramses* while bound for Egypt.) Joly de Lotbinière was also touring the East, not an unusual thing for a wealthy young man to be doing.[14] What was unusual was that he was also making daguerreotypes. He photographed Jerusalem in late February 1840.

Photography provided a new standard of authenticity in pictorial representations. Thus it is not surprising that early photographs, considered the ultimate bearers of "truth," were used as sources for book illustrators. Goupil-Fesquet's daguerreotype view of Jerusalem was carefully reproduced in the form of an engraving in the first book to boast illustrations based on photographs, Nicolas Lerebours's *Excursions Daguerriennes* (1842).[15] Lerebours claimed a superior "truthfulness" for the resulting images in the foreword to the first installment of *Excursions:* "as a result of the newly found precision of the daguerreotype, sites will no longer be reproduced from drawings of the artist, whose taste and imagination invariably modified reality."[16]

It was only a short step from claiming that illustrations based on photographs were the "true" reflection of reality to using photographically-based illustrations as evidence to "confirm" the truth of the Bible. In preparing the 1844 edition of his book *Evidence of the Truth of the Christian Religion Derived from the Literal Fulfillment of Prophecy Particularly as Illustrated by the History of the Jews and the Discoveries of Modern Travellers,* the Reverend Alexander Keith enlisted the aid of his son George to make daguerreotypes. The younger Keith made approximately thirty daguerreotypes, of which eighteen were copied as engravings for inclusion in the new edition.[17] As might be expected from the title of his book, Alexander Keith submitted his first-hand account of the Holy Land, amplified by illustrations based on photographs, "to the unbeliever as the positive evidence of Christianity," and hoped it might "convince the unprejudiced inquirer or the rational and sincere believer, that it is impossible that his faith be false."[18]

Most of the early daguerreotypes of Palestine exist now only in engraved reproductions. Remarkably, a group of almost one hundred plates made by Joseph-Philibert Girault de Prangey in 1842-1843 still survive. As a student of Islamic architecture, Girault de Prangey used the daguerreotype process to make precise records for the study of architectural elements (p. 49). The exquisite detail of the daguerreotype was perfectly suited for recording the intricate architectural ornament characteristic of Islamic architecture.

Early photographers came to the Holy Land for many reasons, some serious, as in the case of the Keiths and Girault de Prangey, others less so. Palestine was an essential stop on the Eastern extension

of the Grand Tour and so attracted gentleman travelers who also happened to be practitioners of the new and exciting art of photography. Many of them used an alternative to the daguerreotype, the *calotype* (a word derived from the Greek *kalos,* meaning beautiful) developed by William Henry Fox Talbot. Talbot's invention, announced in precisely the same year as that of Daguerre, was a negative-positive process which could yield multiple prints. In the calotype process, the photographic chemicals do not lie in a smooth unbroken layer on a metal surface, as they do in the daguerreotype; rather, the solution seeps into the rag fibers of the paper, softening linear detail. Printing the negative onto another paper surface further enhanced this softening effect. If the daguerreotype could enchant with its exquisitely sharp, miniature detail, the paper print emphasized bold compositions of light and shadow or soft atmospheric pictures that critics compared to drawings or etchings. French photographers also experimented with paper negatives and prints, and so the calotype process in its many manifestations became widely used. Most travelers found it simpler and less cumbersome than the daguerreotype process.[19]

One of the wealthy amateurs who traveled and photographed was Ernest Benecke, the heir to an Anglo-German merchant bank with extensive holdings in the East. Between 1850 and 1852, the young man produced over 150 calotypes recording his travels around the Mediterranean and through the East.[20] Naturally, when he passed through Palestine in June 1852, he photographed there (pp. 55, 56). The delicate textural nuances inherent in the calotype process were especially suited to the land and architecture of Palestine. In *View of Herod's Palace, House of David* (p. 55), the softened details of the jumbled houses recreate in an almost tactile way the coarse stone masonry and daubed mud construction of the buildings. Benecke composed the photograph of Hebron (p. 56) in broadly massed bands of light and shadow that hold the burial place of the Patriarchs in delicate balance with the landscape. (In the contrast between Girault de Prangey's daguerreotypes and Benecke's paper prints, we begin to see the ways in which the makers' motives and choice of processes would determine the content and presentation of images. Girault de Prangey's desire for records which he could study dictated the exquisitely detailed architectural study [p. 49],whereas the atmospheric general view of Hebron made by Ernest Benecke was more suited to the traveler's personal souvenir [p. 56].)

The circumstances of the Reverend George Wilson Bridges's photographic odyssey were not as light-hearted as those of Benecke or Girault de Prangey. Bridges traveled around the Mediterranean and through the East with his son in the seven-year period from 1846 to 1852. The two had left wife and mother, daughter and sister buried in Jamaica, victims of a tropical fever they contracted while Bridges was doing missionary work there. In his grief, Bridges threw over his religious duties, returned to England, and, at the urging of friends, turned to travel for solace, hoping that a constant parade of new and exotic places would divert him. Bridges may have learned to make photographs from Talbot's

assistant Nicholaas Henemann while in England immediately after his loss. Did the finicky details and careful concentration required by early paper photography seem a welcome relief from his thoughts? He did not say, although he did record his efforts at photography in his journal. He was not a particularly skilled photographer—his views were often over-exposed and have faded—but it is precisely this ghostly quality, as if looking through layers of time, that is so appealing (p. 54). Arriving in November 1850, he stayed in Jerusalem making photographs for two months until his departure for Egypt in January. Clearly, Bridges was moved by his experience of the Holy Land. The melancholic atmosphere of the city suited his grief and amplified his religious feelings. His exclamation at the sight of Jews praying at the Western or Wailing Wall seems to have something of the personal in it: "What sight, even in this wondrous city, so touching, so impressive as this—Jews mourning the ruins of Jerusalem—Jerusalem now builded as foretold, 'on her own heap.'"[21] Bridges published some of his photographs of the Holy Land as *Palestine As It Is: In a Series of Photographic Views Illustrating the Bible,* which he dedicated to his patroness, the countess of Ellesmere (figure 2).[22]

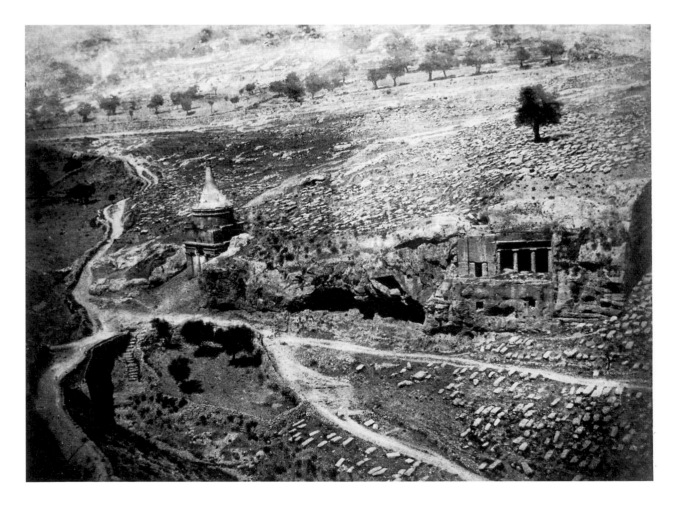

FIGURE 2

THE REVEREND GEORGE W. BRIDGES. *THE JEWS CEMETERY IN THE VALLEY OF JEHOSHAPHAT SHOWING THE TOMBS OF ABSALOM AND ST. JAMES,* PLATE 10 IN *PALESTINE AS IT IS.* ALBUMEN PRINT. PUBLISHED BY J. HOGARTH, 1858. COLLECTION CENTRE CANADIEN D'ARCHITECTURE/CANADIAN CENTRE FOR ARCHITECTURE, MONTRÉAL.

Although Maxime Du Camp and Gustave Flaubert were visiting the Holy City in late August 1850, they had left by the time the Reverend Mr. Bridges arrived.[23] The gulf separating the reactions of an English cleric, steeped in the Bible, from those of the worldly French travelers is immediately apparent. Where Bridges was plunged by the ruins into a melancholic, religious reverie, Flaubert was repelled by the desolation: "Jerusalem stands as a fortress; here the old religions silent rot away. One treads on dung; ruins surround you wherever your eyes wander—a very sad and sorry picture."[24]

The omnipresent sense of decay must have been overwhelming; Flaubert returns to the subject in a letter to his friend the poet Louis Bouilhet on 20 August 1850: "Jerusalem is a house of bones surrounded by walls. Everything is rotting there—in the streets dead dogs, in the churches the religions."[25] Admittedly the two young French *litterateurs* traveled for reasons other than those of Bridges, or of Benecke for that matter. Du Camp and Flaubert went East to soak up sensations and impressions with which to infuse their writing. Du Camp had secured from the French government official backing that eased their travel through the region. While Flaubert, an official emissary of the Department of Agriculture instructed to study agricultural practices, crops, and trade, took his duties very lightly (he joked in a letter to Bouilhet that his official certificate of commission would be most useful as toilet paper), Du Camp's plan for official support involved him in one of the great photographic achievements of the nineteenth century (pp. 50–53). He had approached the Académie des Inscriptions et Belles-lettres and offered his services to photograph any inscriptions or archaeological remains that might be of interest to them.[26] When they responded enthusiastically, Du Camp found himself taking lessons in paper negative photography from the Parisian photographer Gustave Le Gray (he apparently did not know how to make photographs when he offered his services to the academy), and, weeks later, taking photographs in Egypt. Du Camp was quite faithful to his commission. Flaubert confided in a letter to his mother that he was worried that "young Maxime" would crack up under the strain of making photographs in such difficult circumstances. Du Camp persevered and returned to Paris with over two hundred paper negatives from his travels in the East, the vast majority of which were made during the first part of his trip as he sailed up the Nile. When the travelers reached Jerusalem after seven months of hard travel, Du Camp's enthusiasm for photography seems to have waned significantly. Perhaps he found Jerusalem as unpleasant as Flaubert did; only twenty of the two hundred nine photographs he presented to the academy are from the Jerusalem and Palestine portion of his journey. The faded remains of Jerusalem were no match for the awe-inspiring ruins of Pharaonic Egypt. When the travelers arrived in Beirut in September, Du Camp traded all of his photographic equipment for a length of elegant damask with which to drape a divan "fit for an Oriental prince" in his Paris apartment. He did not make a photograph again. He did have the distinction of writing the first travel book illustrated with photographs rather than reproductions of photographs.[27] One hundred and twenty-five of his salted paper prints were tipped into *Egypte, Nubie, Palestine, et Syrie*.

"BRUTE FACTS"

After Girault de Prangey's daguerreotypes of 1843, there was a ten-year hiatus in the application of photography to the archaeological investigation or architectural record of Palestine.[28] The Alsatian painter and archaeologist Auguste Salzmann was the first to use photography systematically as an important adjunct to archaeological work in the Holy Land.[29] Salzmann's photographs were the direct outgrowth of an increasingly acrimonious debate about the relative ages of architectural remains in Jerusalem. It had been generally agreed that nothing remained of the ancient Hebraic kingdom of Solomon and that the ruins scattered around Jerusalem must date from the Roman period or later. But when Louis-Felicien Caignart de Saulcy returned from the Holy Land, the numismatics expert and archaeologist claimed that he had found architectural fragments from the ancient Judean period. More spectacularly, he returned with a fragment of stone removed from one of the burial chambers in the area known as the Tombs of the Kings that he insisted, based on the partially destroyed inscription, dated from the time of King David. This caused an uproar in archaeological circles. Salzmann hoped to resolve the contradiction between de Saulcy's findings and the dates more generally accepted by other scholars. In his introduction to *Jérusalem,* the book of 150 photographs which he published specifically to answer the questions posed by de Saulcy's find, he wrote:

> De Saulcy in his knowledgeable article wreaked havoc with quite a number of commonly held opinions. It had been generally believed that not a single trace of Judaic architecture remained in Jerusalem. With Bible and history book in hand, de Saulcy was trying to prove that monuments previously thought to belong to the Greek or Roman decline were of Judaic origin. In light of these circumstances, I decided that I would be performing a true service to Science by studying and especially photographing the monuments of Jerusalem, especially those whose origins had been questioned.[30]

Salzmann's photographs consist primarily of architectural details, fragments of sculpture, and artifacts from excavations (pp. 57–66). The distant topographic view or standard, middle-distance architectural view that most photographers employed to recreate a sense of place was inadequate for Salzmann's purposes. He developed a characteristic tactic of photographing architectural elements in tight close-up. His compositional strategy was unusual if not unique in this period, and frequently leads viewers of today to describe him as a precociously modern photographer. It is probably more accurate to see our sensibilities, educated in modernist painting strategies that emphasize surface over depth, as exceptionally receptive to the formal elements of his work, although most of us are unable to read the archaeological argument embedded in his pictures. Salzmann concluded his introductory remarks with this often-quoted statement:

"Photographs are not reports, but rather conclusive brute facts." His brute facts, anchored as they are in the dense materiality of his subjects, and composed in dramatic contrasts of dark and light, have become objects for our aesthetic delectation.

Louis De Clercq was the last of this small group of French photographers involved in archaeological research to get to Palestine, arriving in 1859.[31] De Clercq traveled with yet another expedition sponsored by the French Ministry of Public Education (both Du Camp and Salzmann were associated with this ministry). The primary interest of his patron, the geographer Guillaume Rey, was the architectural patrimony expressed in the great castles built by the Crusaders throughout Syria and Palestine.[32] This was a rather straightforward architectural history project much like those of Girault de Prangey and Salzmann, but De Clercq translated what could have been a simple record of ancient castles into a meditation on time and permanence. He also photographed the great urban panoramas of Jaffa and Jerusalem, sites important in the history of the Frankish Kingdoms of the East (pp. 67, 68). He differs from the other French photographers interested in architecture and archaeology, however, in undertaking the most overtly religious project of the French photographers in the Holy Land: a photographic recreation of the Way of the Cross (p. 69).

The French reticence in deploying photography to support or affirm Christian belief should not imply a lack of religious feeling. France as a Catholic country differed from England in the priority it accorded the Bible. While religious training in England was intimately concerned with reading the Bible and integrating its lessons into secular life, French religious instruction centered instead on the elements of the Catholic creed. As a result, the geography of the Bible was as familiar to an Englishman as the geography of his own village or estate, while most Frenchmen would recognize places as being "biblical" without the specificity that came from long study of the Scripture. An English traveler probably could quote scriptural references for every location he passed on his Holy Land tour. An album compiled by an unknown English visitor in the 1870s or 1880s vividly illustrates this close connection between geography and the Bible, something we might term *geopiety*. The photographs in the album, mostly purchased from local studios or commercial photographic publishers in England, are embedded in a web of scriptural references (pp. 122, 123, 126, 127). The association of image and Scripture was not unusual; Frank Mason Good published photographs captioned with apt scriptural tags. The practice reached its apogee with Frances Frith's lavish edition of the Bible, profusely illustrated with photographs (figure 3, p. 29). The anonymous traveler who compiled the album in the exhibition seems to have searched out every scriptural reference to even the most commonplace landscape features. Indeed, for the pious reader of the Bible, all of Palestine was a holy landscape.

THE ROYAL ENGINEERS SURVEYS:
INSALUBRIOUS JERUSALEM

> The city is at present supplied with water principally from the numerous cisterns under the houses in the city in which rain water is collected, but as even the water which, during the rains from December to March, runs through the filthy streets is also collected in some of these cisterns, the quality of the water may be well imagined, and can only be drunk with safety after it is filtered and freed from the numerous worms and insects which are bred in it.
>
> Captain Charles Wilson
> Ordnance Survey of Jerusalem, 1868

It was dangerous to spend much time in Jerusalem in the middle of the nineteenth century. The city was swept by recurrent outbreaks of cholera; plague still made regular appearances; and English missionaries were laid to rest in the English cemetery at an alarming rate, while their luckier fellows returned home with their health broken. The indigenous population did not fare much better. Mrs. Finn, the wife of the British Consul, reported that the hospital founded for the Jews by the London Society for the Advancement of Christianity among the Jews had treated 5,000 patients in 1854, a staggering number when one considers that the total Jewish population of Jerusalem was 9,000. The great public cisterns that had supplied the city for centuries now were fed by run-off from the cemeteries that crowded the hillsides, and the seldom-cleaned Pools of Bathesda and Hezekia were dirty and brackish.

When the *Journal of Sacred Literature* (1864) decided to publish an article by John Whittey on Jerusalem's water supply, a subject that at first glance might seem outside the purview of such a journal, it became apparent that something must be done. A Water Relief Committee was quickly formed, with the dean of Westminster, Arthur Penrhyn Stanley, as chair. The Reverend Mr. Stanley had accompanied the Prince of Wales on his tour of the region in 1862 and presumably would have had first-hand knowledge of Jerusalem's fetid water. (Although given the justly famous quantity of wine carried by the royal party, he may not have had much occasion to drink the water.) Captain Wilson's initial report quoted above confirmed that the concern voiced by the various missionary societies was justified.

The Water Relief Committee determined that the first step was to obtain a complete and accurate survey of the water system and drainage in the city. They called upon the secretary of state for war, Lord Ripon, to provide a team of engineers under the direction of Colonel Sir Henry James, then director of the Ordnance Survey Office, to map the city and all its subterranean water sources. In turn, the committee pledged to underwrite the cost of the survey, although, in actuality, Lady Angelina Georgina Burdett-Coutts

Figure 3

The Holy Bible, English, 1862. (Glasgow: W. MacKenzie, 1862–63). Illustrated with 55 photographs by Frith; issued in an edition of 170 in two plush-lined wooden cases, bound in red morocco with brass edging.

subsidized the entire cost.[33] Lady Burdett-Coutts was as widely admired for her philanthropic work as for her fortune; when she was granted the title of baroness in 1871 in recognition of her many acts of generosity, the Prince of Wales described her as "next to my mother, the most admirable woman in the kingdom." As might be expected, she readily responded to the committee's request for assistance by pledging £500.

Detachments of Royal Engineers with their theodolites, rods, and chains were a common sight in Great Britain. They had meticulously mapped every foot of England and in the process acquired a reputation for exemplary competence. Teams of engineers also were employed throughout the Empire—mapping India, surveying the border between Canada and the United States, cutting roads, and laying rail beds. Captain Wilson had only recently returned from leading the four-year North American Boundary Survey, which marked the entire length of the Canada-U.S. border, when he volunteered to lead the Jerusalem expedition. The Royal Engineers were superbly suited to survey Jerusalem.

Although the reasons for the committee's desire to have the survey carried out by the engineers seem obvious, it is less clear when and how the decision to photograph Jerusalem was made. Captain Wilson had had experience with photography in the field during the North American Boundary Survey. His company photographed natural formations and the aboriginal people they encountered, documenting the members of the survey team, their scouts, and the twenty-foot-wide corridor they hacked through the dense forests of the Northwest as they measured and marked the boundary.[34] Despite, or perhaps because of his familiarity with photography in the field, it appears that Wilson did not think it would be particularly useful in studying the underground cisterns and twisting streets of Jerusalem. In his introduction to the survey, he explained the inclusion of photographs in his finished report: "Photography was not considered an essential part of the survey; the views were taken at spare moments, and were intended to illustrate as far as possible the masonry of the walls and architectural details of the different buildings."[35] As a practical field officer, Wilson certainly would not have burdened his detachment with the cumbersome equipment and supplies required for wet collodion glass plate negative photography which he did not consider an essential part of the task at hand.

We must rather trace this aspect of the project to the interest and enthusiasm of Colonel Sir Henry James, who was eager to see photography established as an integral part of the mandate of the Royal Engineers. James had been interested in photography as a means of reproducing maps since 1855.[36] And indeed, in his preface to the survey, Colonel James claims credit as the impetus for the photographic portion of the survey and for assigning the project to Sergeant McDonald: "In addition to requirements of the [Water Relief] Committee I sent out a photographic apparatus to enable Serj. McDonald, who is both a very good surveyor and a very good photographer, to take photographs of the most interesting places in and about Jerusalem."[37] James's interest is confirmed by his correspondence with Captain

Wilson, now in the archives of the Palestine Exploration Fund, which indicates that he underwrote the cost of the photographic component of the survey.[38]

Colonel James's charge to McDonald, that he photograph "the most interesting places," hardly seems a necessary adjunct to the survey of Jerusalem. McDonald's assignment came, after all, after many commercial photographers, such as Francis Bedford, Francis Frith, and Robertson and Beato, had already made and sold thousands of photographs of Jerusalem and the Holy Land. The Royal Engineers did exploit the commercial possibilities of McDonald's photographs. His views of Jerusalem and the Sinai, as well as stereo cards he made in the Sinai, were offered for sale at the Ordnance Office in Southampton.

When published, the three-volume *Ordnance Survey of Jerusalem* contained eighty-seven photographs, all but three made by Sergeant McDonald.[39] McDonald followed Wilson's field directive in the limited application of photography to the actual work of the survey and made photographs at spare moments to illustrate architectural details and masonry types (pp. 72, 76). The photographs he made of the more mundane details of the city—streets, passageways, and ordinary private homes—also fulfill a survey function (figure 4, p. 32). He fulfilled Colonel James's desire for pictures of sites long associated with the Bible, with photographs such as the Ecce Homo Arch (frontispiece). At first glance, McDonald's photograph of the English cemetery might seem an ironic comment on the public works problem that had brought the engineers to Jerusalem (figure 5, p. 33). It was, however, cited as evidence in the theories advanced about the location of the ancient city walls. Colonel James writes: "So again, if we refer to the photograph of the stairs, No. 37.b., cut in the solid rock in the English cemetery, we know that this was covered up with about forty feet of rubbish; and there can be little doubt but the scarped rocks visible in the cemetery itself extend to a great depth below, and probably formed the southern boundary of the ancient city."[40]

In many of the photographs, members of the surveying party casually lean against walls or perch proudly over rubble-choked passageways (frontispiece, p. 78). A certain sense of ownership is apparent in their attitudes, as if in mapping the city they also laid claim to it.[41] This sense of casual possession was absent when McDonald photographed the burial chambers known as the Tombs of the Kings, an area outside of Jerusalem that had been attributed, since de Saulcy's first expedition, to the time of the Davidian kingdom. There the nonchalant postures have been replaced by much more formal poses. Captain Wilson stands at the very center of the photograph, dwarfed by the yawning opening in the rock face, while McDonald stands at parade rest to the right of the entrance (p. 79). The archaeologist Salzmann's photograph of the same site offers no clue as to scale; the viewer is simply confronted with a great black opening leading to

the tombs (p. 64). Salzmann represented the site as the void of knowledge awaiting study; the entrance is a space to be penetrated in the search for the past. We read something very different in McDonald's photograph; as representatives of the British imperium, the Royal Engineers are deployed in solemn acknowledgment of an earlier empire, one on which they had modeled much of their political discourse.

Sergeant McDonald frequently appears in the survey photographs, usually posed so that we can read the insignia of rank on his jacket sleeve. He probably set up the camera, prepared the plate, and then had an assistant remove the lens cap to make the exposure. We may assume that he had at least one assistant in making the photographs because the wet collodion glass plate negative process was so demanding. The camera had to be set up and focused, and the exposure calculated; only then was the negative prepared in an adjacent dark tent by coating a glass plate with a layer of wet collodion and silver salts. Then the plate, shielded from light in a plate holder or dark box, was inserted into the camera, the exposure made, and the plate rushed back to the dark tent for development before the collodion dried. Authorship of the photographs is always ascribed to McDonald (a credit line appears below the left corner

FIGURE 4

SERGEANT JAMES MCDONALD.
*PRIVATE HOUSES STANDING ON
THE WEST EDGE OF THE TYROPEAN
VALLEY* (OPPOSITE ROBINON'S ARCH),
1864. ALBUMEN PRINT. MICHAEL AND
JANE WILSON COLLECTION.

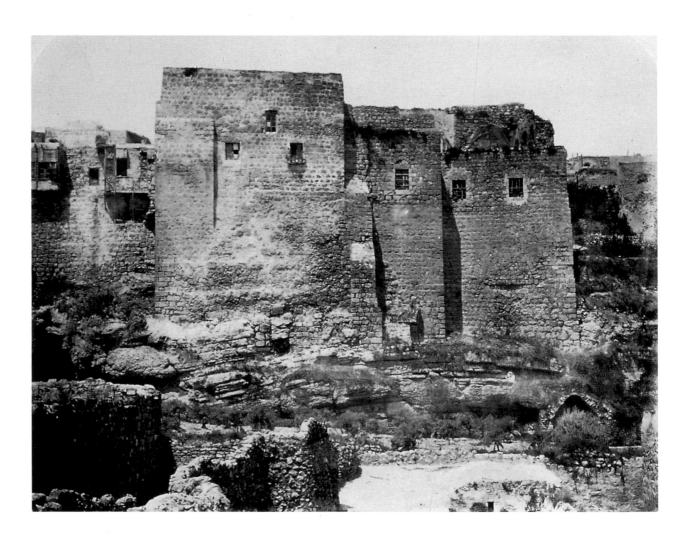

of the prints), but it is very likely that the enlisted men in the party assisted with the sheer work of making photographs. Unlike the photographs McDonald made three years later during the Sinai survey, these do not show members of the expedition at work. No one poses with chain and rod, studies an inscription, or draws an elevation. Wilson's statement that the photographs were made in "spare moments" seems to be borne out by the pictures themselves.

Given the restrictions on his task—that he illustrate famous sites and record architectural details, while using the wet glass plate negative process that rules out much spontaneity—McDonald's pictures have an unusual sense of incident. His photograph of the small square in front of the Church of the Holy Sepulchre (p. 75), a space usually shown as solemnly empty (see, for example, Du Camp's photograph, p. 53, and that of Robertson and Beato, p. 106), registers the flow of daily activity. McDonald's photograph echoes Wilson's description: "Here pedlars from Bethlehem expose their trinkets for sale, and drive a thriving trade with the numerous pilgrims."[42] The scene had not changed much in the twenty years since Alexander Kinglake described it. "The space fronting the church of the Holy Sepulchre soon becomes a kind of bazaar, or rather

FIGURE 5

SERGEANT JAMES MCDONALD.
STAIRCASE IN THE ENGLISH CEMETERY CUT OUT OF THE FACE OF THE ESCARPED ROCK, 1864. ALBUMEN PRINT.
MICHAEL AND JANE WILSON COLLECTION.

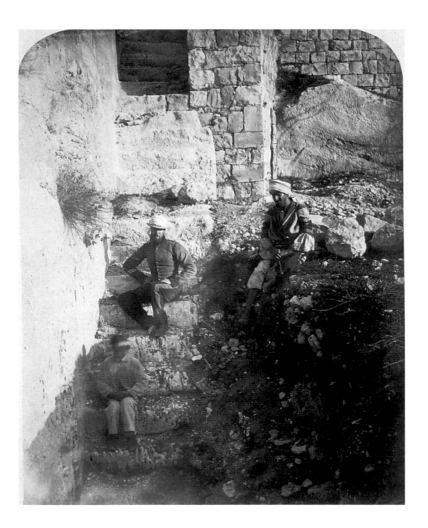

perhaps reminds you of an English fair. On this spot the pilgrims display their merchandise, and there, too, the trading residents of the place offer their goods for sale. I have never, I think, seen elsewhere in Asia so much commercial animation as upon this square of ground by the church door. . . . "[43]

A robed and bearded Eastern Orthodox priest paces among the peddlers, waiting to escort visitors into the church (p. 75). (The Church of the Holy Sepulchre is a perfect example of the tangled skein of religious privileges. It was under the protection of six different denominations, although the keys were held by an Islamic gatekeeper.) McDonald's view of the double window at the Church of the Holy Sepulchre, a detail photographed by almost everyone who visited Jerusalem because of the accretion of architectural ornament (see Salzmann, p. 58), is enlivened by the robed figure sitting in the window (p. 76).

At some point during the expedition, either some of the glass negatives or prints made from them were sent back to England.[44] Sir Moses Montefiore recorded in his diary a visit to the Ordnance Survey Office at Southampton on 9 February 1865. He had a long meeting with Colonel James "with reference to the survey of Jerusalem then being carried out by a party of engineers belonging to that department—

FIGURE 6

SERGEANT JAMES MCDONALD.
WALL SOUTH OF WAILING PLACE, 1864.
ALBUMEN PRINT.
MICHAEL AND JANE WILSON COLLECTION.

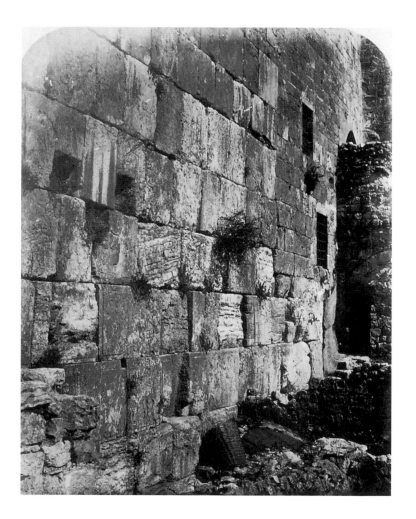

Sir Henry presented him with a beautiful photograph of the wailing wall at Jerusalem, with which Sir Moses expressed himself highly gratified."[45] It is quite likely that the print Sir Moses was presented with was this beautiful view of the Jews's most sacred spot (figure 6, p. 34). It seems that Colonel James put McDonald's photographs to use as public relations tools to increase interest and support for the work. Excited by the antiquity of the structures he was surveying, Wilson was requesting further funds to support excavations.[46] Colonel James's public relations were effective; six days later at a meeting of the Syrian Improvement Fund Committee, Sir Moses Montefiore proposed a disbursement of £100 from the committee's funds "for the use of Captain Wilson and the engineers at Jerusalem towards the expense of excavations, etc., for the purpose of finding a mode of providing Jerusalem with a better supply of water."[47] Sir Moses, as a founding member and the committee's most influential voice, saw his proposal quickly approved.

It is instructive to compare the initial charge to the Royal Engineers with the actual scope of their work. Their task, as originally requested by the Water Relief Committee and represented to Lady Burdett-Coutts, to Izzet Pasha, the Turkish governor of Palestine, and subsequently to Sir Moses Montefiore, was to trace the water system in the city, identify the portions of it that had fallen into disrepair, and recommend corrective measures. In fact, Wilson's team accomplished much more. They completed an exquisitely detailed map of Jerusalem, including elevations for the city and surrounding promontories. They surveyed and mapped the citadel where the Turkish troops were garrisoned and noted the position and condition of the cannons there; they conducted excavations; and they "levelled" (that is, they precisely measured changes in elevation) to the Dead Sea. The engineers had collected a great deal of information beyond the position of cisterns and water channels: "The party completed its labours, and embarked at Jaffa on the 16th June, and returned to England on the 10th July 1865, without any casualty and without having suffered much from sickness."[48] The survey team brought back inspiring news. Far from having vanished, there were important archaeological discoveries waiting to be made in Jerusalem and Palestine. While Wilson, McDonald and their four men were still at sea on their way to England, and before their findings, maps, and photographs were published, the society that owes its inception to their work, the Palestine Exploration Society, was formed.

FOR GOD AND EMPIRE: THE ROYAL ENGINEERS AND THE PALESTINE EXPLORATION FUND

> This country of Palestine belongs to you and me, it is essentially ours. . . . It is the land towards which we turn as the fountain of all our hopes; it is the land to which we may look with as true a patriotism as we do this dear old England which we love so much.[49]

Loud cheers greeted the opening remarks made by William Thomson, archbishop of York. It was 22 June 1865 and the organizational meeting for the Palestine Exploration Fund was under way. Although Wilson and his surveyors were still enroute from Jerusalem, their survey had inspired the organization of a society dedicated to the scientific exploration of Palestine. Colonel James claimed the Jerusalem Survey as the catalyst for the Palestine Exploration Fund:

> Since the completion of this survey, a Society has been formed under the patronage of Her Majesty the Queen, which is called the "Palestine Exploration Fund," the first meeting of which was held on the 22nd June 1865, His Grace the Archbishop of York in the chair, and I am much gratified to state that from the very satisfactory manner in which Capt. Wilson carried out my instructions for the survey of Jerusalem, the levelling to the Dead Sea, etc., he has been selected to go out as the chief director of the explorations to be made by the new society which has been formed, but although I am deeply interested in the success of the new expedition, in my official capacity I have nothing whatever to do with it.[50]

Despite Colonel James's closing disclaimer, the personnel of the Royal Engineers and the conduct of the Palestine Exploration Fund's expeditions were inextricably intertwined from the start.[51] George Grove, a member of the Water Relief Committee, was a driving force behind the fund's establishment. Both he and Colonel James had laid the groundwork by orchestrating public interest in the water survey; both had written letters to the *Times* enthusiastically describing the progress of the project and the discoveries made in the course of the survey, while bemoaning the things that still needed to be investigated, if only there could be found funds to support the team in the field. Their letters were but a public manifestation of the behind-the-scenes recruitment upon which Grove embarked. For any sort of society to prosper in Victorian England, the right mix of socially and intellectually prominent founding members and subscribers was essential. Grove masterfully involved every major faction in the circles of power—churchmen of all shades of belief, appropriate political figures, the Jewish magnates Montefiore and Rothschild—and, perhaps his most important coup, he enlisted the queen as the royal sponsor of a society dedicated to the study of the Holy Land.

Born in 1820, the year after the queen, and predeceasing her by only a year, George Grove incarnated the energy, enthusiasm, and intellectual eclecticism so typical of the Victorian era. Today we know him principally as the editor of the musician's bible, *Grove's Dictionary of Music and Musicians,* but he was also a well-known biblical scholar, as well as the superintendent of the Crystal Palace. In his biblical investigations, he had visited the Holy Land and compiled extensive lists of geographical locations and personal names occurring in the Bible. He found his efforts to establish a geographical index correlated

with contemporary place names significantly hampered by the lack of accurate maps. Perhaps because he was trained as an engineer himself, he realized that a survey of this magnitude required the participation of the Royal Engineers. From the outset, he was a strong advocate for a role for the Royal Engineers in the exploration of Palestine.

The prospectus for the Palestine Exploration Fund was read out by Archbishop Thomson at the organizational meeting: "Our object is strictly an inductive inquiry. We are not to be a religious society; we are not about to launch any controversy; we are about to apply the rules of science, which are so well understood by us in other branches, to an investigation into the facts concerning the Holy Land."[52] It concluded with the desire that the society should undertake to fund "an expedition composed of thoroughly competent persons in each branch of research with perfect command of funds and time, and with all possible appliances and facilities, who should produce a report on Palestine which might be accepted by all parties as a trustworthy and thoroughly satisfactory document."

The fund was launched and, with a coffer of £300, its directors commissioned Captain Wilson to return to Jerusalem with another officer from the Royal Engineers, Captain Charles Warren. They were directed to excavate around the outer walls of Jerusalem to determine the depth to bedrock, and to locate the outlines of the ancient city and the foundations of the great temple.[53] Warren returned to excavate around Jerusalem for the next three seasons, each time with the support, minimal as it might be, of the PEF.

The first official survey for the PEF went out under the command of officers of the Royal Engineers with a team of noncommissioned surveyors and sappers (or excavators) in the fall of 1865. This was to be the template for almost all future expeditions underwritten by the PEF in the nineteenth century.[54] The roll of officers who led survey teams for the PEF reads like a "Who's Who" of the British military, with a preponderance of connections to military intelligence in the region. In the course of his career with the Royal Engineers, Charles Wilson commanded the Sinai Survey, and participated in numerous border surveys in the Near and Middle East. His career skated particularly close to the thin line between expeditionary surveying and military intelligence gathering. He translated the text "Strategic Importance of the Euphrates Valley Railway," the theoretical blueprint for Germany's plan to build and control a rail corridor from Berlin to Baghdad that would in turn become a key issue in the struggle for control of North Africa during World War I. As head of intelligence in Egypt and the Sudan, he was harshly criticized after the fall of Khartoum and the death of General Gordon.

After his excavations in Jerusalem, Charles Warren went on to have a full military career in Egypt (in the intelligence section) and various divisions of South Africa, and performed heroically in the Zulu wars. (Unfortunately, this distinguished career ended on a less than stellar note; Jack the Ripper began his carnage while Warren was the commissioner of the London Metropolitan Police.)

Claude Regnier Conder must stand as the paramount example of the connections between military surveying and the Palestine Exploration Fund's program of scholarly research. From 1872 when he was first assigned to the Royal Engineers's mapping project in Palestine, Conder committed the rest of his life to the exploration of the Holy Land. He oversaw the multi-year project to map the entire area and remained fiercely proud of the accomplishments of his Royal Engineers. He became a recognized authority; translated the El-Amarna tablets; and produced a virtual stream of publications, general and scholarly, on the history of Palestine. Conder was a superlative survey commander; his maps remained the definitive documents on Palestinian geography well into the twentieth century and were used by the British army in military operations in Palestine. Another of the PEF surveyors, Herbert Horatio Kitchener (figure 7), became the hero of Khartoum. Kitchener mapped western Palestine with his friend Conder, surveyed Galilee, and served in military intelligence. In 1913, as Lord Kitchener of Khartoum, he recruited the young archaeologist T. E. Lawrence to survey and photograph the Wilderness of Zin, the one area of Palestine not previously

FIGURE 7

H. H. KITCHENER.
CONDER AT ELISHA'S FOUNTAIN AT JERICHO, FROM *PHOTOGRAPHS OF BIBLICAL SITES BY LT. H. H. KITCHENER, RE., F.R.G.S.*, 1874–1875. ALBUMEN PRINT. GERNSHEIM COLLECTION, HARRY RANSOM HUMANITIES RESEARCH CENTER, THE UNIVERSITY OF TEXAS AT AUSTIN.

surveyed and a crucial link in the defense of the Suez Canal.[55] And so began the career of Lawrence of Arabia as intelligence agent and power broker in the Middle East.

These connections may make the PEF seem suspiciously like an umbrella organization for British military intelligence. However, the first general secretary of the PEF, novelist Walter Besant, describes a quiet organization as attractive to eccentrics and cranks as it was to intelligence-gathering operatives.

> A Society such as the Palestine Exploration Fund naturally attracts all the cranks, especially the religious cranks. There was one man who was a mixture of geographical science and of religious crankiness. He claimed to be the son of the founder of the Plymouth Brethren; he had vast ideas on the rebuilding of Babylon, that it might once more become the geographical centre of European and Asiatic trade. As a matter of fact we only have to consider the position of Babylon in order to understand that when the country is taken over by a European Power, and the valley of the Euphrates is once more drained and cultivated, that great city will again revive. But with this insight he mixed up a queer religion in which Nimrod played a great part. He would talk about Nimrod as long as I allowed him. And then I heard of a grand project in which he was concerned. It was nothing less than the cutting of a sea-canal from the northern end of the Gulf of Akaba to the South of the Dead Sea; this canal would flood the Jordan Valley and create a large central lake over that valley extending for some miles on either hand. Then, with a short railway across Galilee, there would be a new waterway, with possible extension by rail and canal to Persia and India. The project was seriously considered; a meeting was held in the Office of the Palestine Exploration Fund, at which the then Duke of Sutherland and others consulted Sir Charles Warren and Captain Conder on the possibility of constructing the canal. The Duke could not, or would not, be persuaded that a cutting of so many miles of seven hundred feet deep at least would be practically impossible. I think there must have been some political business at the back of the project, of which, however, nothing more was heard.[56]

Besant was probably dead right in ascribing "some political business" to the project. He does seem to have had his share of visitors with unusual interests and schemes to propose to the Fund and to have handled them with exquisite courtesy. The fellow who could read any and all ancient inscriptions by his knowledge of the original alphabet, which he had discovered to be constructed entirely of equilateral triangles, "was amusing at first but became tedious."[57] Another who saw the telltale evidence of "nature worship" in everything ancient was tedious from the start. And then there were the reactions to the published results of the society: "The man who could prove that Mount Sinai is not Hor and that the survey of the Sinai peninsula was therefore a useless piece of work, wrote a book about it, and so relieved his mind."

Over the next twelve years, the PEF would send out expeditions composed at least partially of members of the Royal Engineers to map all of the Holy Land. Now in its 132nd year, the PEF has remained faithful to its founding statement by remaining resolutely nonsectarian. They have been a neutral source of support for scholarship in the region.

ALONG MOSES'S PATH:
THE SURVEY OF THE SINAI PENINSULA

The Survey of the Sinai Peninsula had an expanded cast of characters beyond that of the Jerusalem Survey, no doubt because the mission of the Sinai Survey was more complex and required a variety of skills beyond those of the cartographer. Once again it was organized under the supervision of now Major General Sir Henry James, director general of the Ordnance Survey; jointly commanded by Captain Wilson with Captain H. S. Palmer; and again it included McDonald, recently promoted to colour sergeant. In addition to those who might be considered to be primarily involved in the technical aspects of mapping, the party included a biblical scholar, the Reverend George Williams, and Cambridge Fellow E. H. Palmer (no relation to Captain Palmer), an Orientalist skilled in ancient and contemporary languages of the region. C. W. Wyatt went along as the natural historian and the Reverend F. W. Holland accompanied the expedition and assisted in almost every field of study.

In the introduction to the published account of the expedition, the Reverend Mr. Williams defined their goal: "That there is a great need to carry out such a survey must be manifest to all students of Old Testament history; among the most important and interesting questions which are now subjects of inquiry [are the locations of] the Passage of the Red Sea, the Route and Encampment of the Israelites, and the identification of the Mountain of the Law-Giving."[58]

James and the Reverend Mr. Holland solicited subscribers to finance the project, using the success of the survey of Jerusalem as evidence of what might be expected. Cambridge and Oxford both pledged support, as did the Royal Society and the Royal Geographic Society. James and Captain Palmer also contributed to the fund. With £2000 in hand and the assurance of the ever-generous Lady Burdett-Coutts that "she would not let the project fail for want of money," the entire contingent departed for Alexandria on 24 October 1868. By 12 November, they were at the Wells of Moses, the place where caravans and travelers took on their last supplies before attempting the four-hundred-mile journey across the desert (p. 81). By tradition, this was the place where the Israelites had rested after being freed from Egypt and before crossing the Sinai to their homeland.

The objectives of the expedition were couched in terms of biblical research:

In drawing up my instructions for the officers in charge, I gave directions for special surveys to be made of Jebel Musa and Jebel Serbal, the two "rival mountains," as they have been called, for the honor of being the Mount Sinai of the Bible. I gave directions for these surveys to be carried out with scrupulous care, and in such detail that accurate models of both mountains could be made from them. The model of Jebel Musa was actually made on the ground by Corporal Goodwin, who had been provided with materials for this purpose . . . The model of Jebel Serbal was also partly made in Sinai, and completed immediately after the return of the party to Southampton, from the detailed plan of the Survey and a number of photographic views. . . . [59]

No published description of the project mentioned the nearly completed canal that the French and Egyptians were building across the Isthmus of Sinai. (The Suez Canal would open to great fanfare in November 1869.) Nevertheless, it cast a long shadow over any discussion of the Sinai. It was essential to have a clear understanding of the geography around this vital link.

Photography on this survey was an integral part of mapping the land. McDonald made several large panoramas that convey a sense of the expanse of the desert, mountain ranges, and valleys they encountered (pp. 84, 86, 87). Early into the expedition, he photographed their campsite beneath the jagged formations they would map in the next three months (p. 83). Unlike the survey of Jerusalem, this expedition saw McDonald recording members of his party at work, as in this photograph of Mr. Palmer noting inscriptions (figure 8, p. 42). McDonald made portraits of the expedition guides and the Bedouins who accompanied them (pp. 101, 151). In one view, a guide leans proudly against a stele he had located for the officers—they had alerted their guides to their interest in rock inscriptions and the guides scrambled to find them (p. 98). Although McDonald photographed some of the incised rocks, he generally contented himself with recording their situation, frequently including their finder (p. 100). Palmer and the others would make careful drawings of the markings.

More than three hundred photographs were made during the course of the expedition. The photographic undertaking alone required a large contingent of bearers and draft animals to carry hundreds of glass plates, gallons of solutions, and the bulky camera itself. McDonald selected topographic subjects that expand our sense of the land beyond what can be read from a map. He photographed details of their researches and incidents of their travel. As requested by James, he photographed the Convent of Saint Catherine, while Captain Palmer had plans and elevations drawn (pp. 88, 89). It seems that in every way photography was integrated into the complex work of the survey.

The immensity of the Sinai, open and barren, was almost untranslatable to the medium of photography. Distance and scale suddenly snap into focus in a view of Jebel Serbal from Jebel Tahuneh, when we notice the tiny figures on the promontory in the right panel of the panorama (p. 86). The view titled *Plain of Er Ráhah from a Cleft on Rás Sufsáfeh* speaks to the barren expanse still before the travelers (p. 90). Again and again, McDonald returns to the meticulously crafted panorama to register the topography of the land. Members of the expedition are posed across first one frame and then another of the panorama of Wady Ed Deir (p. 84). Making a seamless panorama must have taken hours. The camera had to be set and leveled for each exposure. Only then could the photographer begin the complex choreography of sensitizing the glass plate negative, exposing it, and developing it before it dried. While McDonald attended to this complex preparation, perhaps with the assistance of one of his men, his companions would have positioned themselves in the next segment of landscape in the panorama to await the next exposure. Considering the distances

FIGURE 8

SERGEANT JAMES MCDONALD.
WADY MUKATTEB, SHOWING ROCK INSCRIPTIONS, 1868–1869.
ALBUMEN PRINT.
MICHAEL AND JANE WILSON COLLECTION.

represented in some of these panoramas (see, for example, p. 84), this was not a matter of moving just a few paces, but required hiking over several hundred yards of rough terrain. The skill of a surveyor and a topographer's sensitivity to the forms and masses of landscape are combined in these superb panoramas.

In describing the work involved in the survey, Captain Palmer turned to McDonald's photographs to convey a true sense of the rugged terrain:

> Before closing this account of the special surveys, it might not be uninteresting to place on record a few particulars of the details of our daily work and the sort of obstacles we had to overcome. The dry recital of technical details which has been given furnishes but little indication of the actual difficulty and labour of the work. The trigonometrical stations, as has been explained, were often at tremendous heights and for the most part at long distances from our camps, and the country was so rugged and confused, and so deeply cut by intersecting ravines, that it was sometimes a good day's work to get to and from a single station. The walking in the smaller wádies and ravines, especially those around Serbál, was fatiguing beyond measure, the whole surface being strewn with boulders . . . and rock fragments of every size. . . . Three or four weeks of real mountain and valley work in Sinai would destroy the best boots or shoes that were ever made. . . . But perhaps a reference to some of the photographs will give a much better idea of its character than any attempt at verbal description.[60]

McDonald's photographs were available for purchase at the Ordnance Survey Office in Southampton, as were stereo views from the survey. The stereo views were offered as a set of seventy-five cards, many of which did not appear in the published *Ordnance Survey of the Peninsula of Sinai*.

Five months after entering the barren expanse of the Sinai, members of the Survey packed up and went their separate ways. Captain Palmer noted laconically, "The general survey was finished on the 16th of April; six days later we turned our faces homeward."[61] Some of the company would return to the region for other projects. Both Palmers returned, Captain Palmer to assist with other surveys, and Edward Palmer, skilled in the languages and dialects of the region, was recruited by British intelligence in Cairo to negotiate with desert tribes for their support of British actions in Egypt. He was killed by bandits while crossing the Sinai with a large amount of cash destined to secure the loyalty of the tribes. It was Warren who conducted the search for Palmer and recovered his body from the Sinai; he then returned to England. The clerics in the party returned to Jerusalem in various religious and scholarly capacities over the course of the next few years. Sergeant McDonald continued his rise through the ranks and remained in England in various supervisory positions in the Royal Engineers. He served as quartermaster and retired with the rank of captain. He did not return to the Holy Land.

THE COLLODION MAP

Photographing the land is never a neutral undertaking because our relationship to land is itself not neutral. Pictures of the land bring up issues of possession and right, indicate poverty or bounty.[62] Land can be discussed as a commodity or a sacred trust. In the nineteenth century, the land of Palestine was a hotly-contested geography of imperial necessity, spiritual inheritance, and, quite literally, unknown territory that required mapping. The land that the Royal Engineers surveyed and that Sergeant McDonald photographed was more than a place to be added to the Empire; it was a territory of belief, and an arena for intellectual inquiry. Britain's engagement with and possession of the Holy Land derived from a set of political realities—the diminishing power of the Ottoman Turks and the necessity to secure the land routes to India, Britain's richest colonial treasure—and from a constellation of cultural assumptions that read English history and geography in Old Testament terms.

Any pictures made in the Holy Land by and/or for the English carried these complex claims and associations. The photographs of Palestine that speak most directly to England's tragic assumptions about this land are the military survey photographs.[63] As the surveys were hybrid creatures—privately financed but directed by the military, focused on biblical archaeology but producing that most quintessentially useful of military tools, accurate maps—so their offspring, the survey photographs, seem to inhabit two worlds. They move beyond the commercial "views" that repeat the same presentation of sites for a market that "knows" what it wants, pictures that conform to the customer's understanding of a place. Sergeant McDonald's photographs ranged even beyond the concerns of the investigator and recorder of architectural and archaeological elements. They imagine a literal possession of the spiritual geography of Jerusalem in the attitudes that members of the survey team, and Sergeant McDonald himself, strike as they arrange themselves on and over the principal sites of Holy Scripture. The multiplicity of subjects McDonald photographed in the Sinai assert the extent of British possession. Everything—ancient scripts, native peoples, the manifestation of different religious practices, historical sites, and the land itself—is the intellectual property and physical space of English domination. McDonald's sweeping panoramas of the Sinai supply the topographical elevations for the maps that the engineers were drawing.

Ultimately, McDonald's photographs are powerful visual statements of the imperial, cultural, and intellectual assumptions that England made about Palestine in the nineteenth century. They invite us to look beyond the subject matter that is still relevant to us today, and to probe further than their formal aesthetic qualities as images. It is considered axiomatic in science that the simplest and most elegant propositions can carry the most complex implications. McDonald's photographs, strong, simply composed images, transmit very complex messages.

NOTES

1. For a discussion of the range of nineteenth-century reactions to Jerusalem, see Nitza Rosovsky, "Nineteenth-Century Portraits through Western Eyes," in *City of the Great King: Jerusalem from David to the Present,* ed. Nitza Rosovsky (Cambridge, Mass., and London: Harvard University Press, 1996).

2. Benjamin Disraeli's visit to the East was to have important ramifications in his political life and in his writings. Robert Blake, *Disraeli's Grand Tour: Benjamin Disraeli and the Holy Land 1830–31* (Oxford: Oxford University Press, 1982), cites Disraeli's reaction as recalled in his autobiography.

3. W.H. Bartlett, *Walks about the City and Environs of Jerusalem* (London, 1843).

4. Thackeray is cited by Rosovsky, "Nineteenth-Century Portraits," 230, in *City of the Great King.*

5. See Appendix for a short biography of Sergeant McDonald.

6. This is not intended to be a comprehensive history of photography in the Holy Land. The principal histories are Yeshayahu Nir, *The Bible and the Image: The History of Photography in the Holy Land, 1839–1899* (Philadelphia: University of Pennsylvania Press, 1985); and Nissan Perez, *Focus East: Early Photography in the Near East (1839–1885)* (New York: Harry N. Abrams, 1988). The photographs of Jerusalem and the Holy Land that are most familiar to us today are those made by Francis Frith, Francis Bedford, Charles Mason Good, and the team of Robertson and Beato. In each case, the photographers are generally associated with the commercial production of "views" for sale in the growing photographic market. The case of Francis Bedford is slightly different; he was commissioned to photograph the Prince of Wales's Middle Eastern Tour of 1862. His status as part of the royal party gave him special access to many of the sites holy to Islam. Although the photographic work was commissioned, Bedford retained control of the negatives for commercial use. He published and sold many views from the tour. For a discussion of "view photographers" and Bedford and Frith in particular see Howe, *Excursions Along the Nile: The Photographic Discovery of Ancient Egypt* (Santa Barbara, California: Santa Barbara Museum of Art, 1993).

7. Barbara Tuchman in *Bible and Sword: England and Palestine from the Bronze Age to Balfour* (1956; reprint, New York: Ballantine Books, 1984) traces British interest in the Holy Land to long-standing traditions that identified the earliest Britons as descendants of Noah's grandson Gomer, converted to Christianity by Joseph of Arimathea (the source for the legend of the Holy Grail), and connected to the Phoenicians of Biblical times through trade. This origin myth was only amplified by various religious trends that revered the Bible.

8. Today Thomas Henry Huxley is perhaps best known for defending Darwin's *Origin of Species* (1859) in a debate with Bishop Wilberforce before the British Association for the Advancement of Science at Oxford. Huxley had a distinguished career as a naturalist. He was a pivotal figure in the educational reform movement sweeping England at mid-century. His hand may be seen in the change from a great books type of curriculum, which defined the edu-

cated as those who could read and compose couplets in Greek and Latin, to a curriculum that gave equal weight to the sciences and mathematics. Although the impact that this reform had on the general curriculum was significant, it was especially so in the sciences. Perhaps more than any other man in England, Huxley has the distinction of making science independent of theology. As he claimed, "A deep sense of religion is not incompatible with a total lack of theology."

9. The League of Nations mandated that Britain "assume" the administration of Palestine (the British were, of course, already in control following Allenby's victory at Jerusalem) and serve as the region's "tutor" in the transition to self-determination. The Balfour Declaration was a statement of British policy supporting "the establishment in Palestine of a national home for the Jewish people." There is an extensive bibliography dealing with the history of Britain's mandate to govern the lands of the Middle East which they had seized from the Turks in the First World War. A readable general history is Tuchman's *The Bible and the Sword.*

10. Quoted in Charles Batten, *Pleasurable Instruction: Form and Content in Eighteenth-Century Travel Literature* (Berkeley: University of California Press, 1978), 1.

11. Roberts' compositions were drawn on the stone by the lithographer Louis Haghe. *The Holy Land* was issued in two formats, one with color lithographs and a less expensive edition with tint lithographs.

12. Reviews from *The Art-Union* of 1842 and *The Athenaeum* of 1847, quoted by Briony Llewellyn, "Roberts' Pictures of the Near East," in *David Roberts,* comp. Helen Guiterman and Briony Llewellyn (London: Phaidon Press and Barbican Art Gallery, 1986), 72. Llewellyn's essay is the most complete discussion of Roberts' Eastern subjects and the context in which they were exhibited and published.

13. Quoted by Llewellyn from Ruskin, *Modern Painters,* Vol. 1, 1843.

14. I am grateful to Joan Schwartz of the Canadian National Archives for providing me with the typescript of the translation of Joly de Lotbinière's journal prepared by Sylvie Gervais from papers conserved in the Archives nationales du Quebec. Specific information regarding his movements in the East is derived from this translation. Joly de Lotbinière arrived in Palestine later than the Vernet/Goupil-Fesquet party because he had made the journey up the Nile to Abu Simbel. Then, when he arrived in Jaffa in February, he had a fever and so was quarantined until the end of February 1840. His views were reproduced in *Excursions Daguerreinnes.*

15. Photographs could not be printed as book illustration until the invention of the half-tone process in the 1880s. This was especially true of the daguerreotype, a unique photographic positive on a polished metal plate. Goupil-Fesquet's daguerreotype of Jerusalem was copied as an engraving for the book. Short biographical entries for early photographers in the Middle East may be found in Nissan Perez, *Focus East.* Many of the photographers who went to Palestine also traveled in Egypt, in which case bio-

graphical entries may be found in Howe, *Excursions Along the Nile: The Photographic Discovery of Ancient Egypt.*

16. *Excursions Daguerriennes – vues et monuments les plus remarquables du globe* (Paris: Lerebours, 1842), i.

17. The elder Keith himself may have attempted photography on an earlier visit. It appears that he had some instruction in the calotype process but was not successful in making photographs in Palestine. His writings were very popular; the 1844 edition was the thirty-sixth edition of the book.

18. *Evidence of the Truth of the Christian Religion Derived from the Literal Fulfillment of Prophecy Particularly as Illustrated by the History of the Jews and the Discoveries of Modern Travellers* (Edinburgh: W. Whyte, 1844), xii.

19. The principal source for discussion of the characteristics, history, and practioners of paper photography as used by the French is André Jammes and Eugenia Parry Janis, *The Art of French Calotype, with a Critical Dictionary of Photographers, 1845–1870* (Princeton: Princeton University Press, 1983).

20. Benecke's photographic output is unique in that he made several portraits of the people in the region, a practice practically unknown at the time. For a short biographical entry on this interesting and little-known photographer, see Howe, *Excursions Along the Nile,* 157.

21. *Palestine As It Is: In a Series of Photographic Views Illustrating the Bible* (London: J.W. Hogarth, 1858–1859), n.p.

22. *Palestine As It Is* is a small collection of twenty-one prints, intended to be part of a larger work, a proposed multi-folio collection titled *Selections from Seventeen-Hundred Genuine Photographs: (Views, Portraits, Statuary, Antiquities) Taken Around the Shores of the Mediterranean Between the Years 1846–52. With, or Without, Notes, Historical, and Descriptive. By a Wayworn Wanderer.* The entire project was never completed and the publication history of its various elements is famously murky. It does appear that Bridges' decision to publish after a lapse of six years was prompted by the commercial success of other later photographic records of the Holy Land, especially that of Francis Frith. See the biographical entry for Bridges in Richard Pare, *Photography and Architecture: 1839–1939* (Montreal: Canadian Centre for Architecture, 1982).

23. This section on Du Camp's Eastern tour is based on research undertaken for my dissertation, "Egypt Recovered: The Photographic Surveys of Maxime Du Camp, Félix Teynard, and John Beasley Greene, and the Development of Egyptology" (Ph.D. diss., University of New Mexico, 1996).

24. Gustave Flaubert, *Voyage en Orient* (1849–1851), Oeuvres complètes (Paris: Centenaire Libraire de France, 1925), 147.

25. *Ibid.,* 152.

26. The Académie des Inscriptions et Belles-lettres was the primary institutional force in French archaeology. Most of the early French photographers who

recorded ancient monuments—J.B. Greene, Auguste Salzmann, Maxime Du Camp, Victor Place, Pierre Tremaux—received instruction and encouragement from this branch of the French Academy.

27. Maxime Du Camp, *Egypte, Nubie, Palestine et Syrie, dessins photographiques recueillis pendant les années 1849, 1850 et 1851, accompagnés d'une texte explicatif et précédés d'une introduction par Maxime Du Camp* (Paris: Gide et Baudry, 1852).

28. Although Du Camp was given a list of sites and artifacts to photograph by the Académie des Inscriptions et Belles-lettres, his work could not be described as archaeological in any sense of the word. Du Camp mostly ignored the Academy's list and photographed the views and imposing ruins that appealed to him.

29. François Heilbrun, "Photographies de la Terre Sainte par Auguste Salzmann," in *Félix de Saulcy (1807–1880) et la Terre Sainte* (Paris: Réunion des musées nationaux, 1982), 114–182.

30. Auguste Saltzmann, *Jérusalem. Etudes et reproductions photographiques de la Ville Sainte depuis l'epoque judaïque jusqu'à nos jours,* 2 vols. (Paris: Gide et Baudry, 1856), 3.

31. The definitive publication on De Clercq is Eugenia Parry Janis, *Louis De Clercq, Voyage en Orient* (Cologne: Edition Cantz, 1989).

32. Rey's survey of the castles left by the Crusaders may be seen as a logical outgrowth of the French interest in preserving the monuments of her past, an interest that inspired Victor Hugo's *Notre Dame de Paris* and spurred the creation of the Commision for Historic Monuments. For a discussion of the influence of the Commission on photographic practice in the 1850s, see Jammes and Janis, *The Art of French Calotype,* 52–67.

33. Lady Burdett-Coutts is another extraordinary Victorian with far-ranging philanthropic interests. She endowed bishoprics, parishes, and schools throughout England and the colonies; worked for educational reform; and established a model housing area, school, and church in London. During the Famine, she contracted with the Cunard line to assist in the mass emigration from Ireland. She continued to support explorations and surveys in Palestine, contributing to the Sinai Survey.

34. For a history of photography as practiced by the Royal Engineers, see John Falconer, "Photography and the Royal Engineers," in *The Photographic Collector* 2, no. 3, (Autumn 1981): 33–64. Falconer does not discuss the Palestine Surveys in any detail but provides description of surveys undertaken at about the same time in North America and Abyssinia.

I would like to thank Andrew Brettell, Joan Schwartz, and Lily Koltun of the National Archives of Canada for making the photographs from both the Boundary Survey and Abyssinia available and for sharing their very useful perspectives on the engineers' photographic legacy.

35. Wilson, *Ordnance Survey of Jerusalem* (London: Authority of the Lord Commissioners, 1865), 18.

36. The obituary notice for James McDonald emphasized his close connection with James' pet project from its inception; see Appendix. Falconer, "Photography and the Royal Engineers," does not assign a significant role in developing photography in the engineers to either McDonald or James.

37. James, preface to *Ordnance Survey of Jerusalem,* 1.

38. I am very grateful to Shimon Gibson, photo-archivist of the Palestine Exploration Fund, for graciously sharing the results of his research in the P.E.F.'s archives. He brought to my attention the letters between Captain Wilson and Colonel James regarding photographic supplies and support.

39. Some of the photographs from the *Ordnance Survey of Jerusalem* that appear in the accompanying exhibition are from a private album of seventy albumen prints in which titles and attributions are hand-written below the photographs. The binding for this album is very similar to the binding used for the official publications—it bears the crest of the engineers—so it most probably represents a collection of photographs made for a ranking officer of the Royal Engineers or a sponsor of their work.

The others were taken by Peter Bergheim, identified as a local photographer. See Perez, *Focus East,* 135–136; or Nir, *The Bible and the Image,* 117–121.

40. James, *Ordnance Survey of Jerusalem,* 8.

41. The sense of possession experienced by many English visitors to Palestine is noted in Tuchman's *Bible and Sword.* She points out that Jerusalem, as an idea, had become a governing metaphor for elements of English political life, in addition to its obvious religious associations.

42. Wilson, *Ordnance Survey of Jerusalem,* 48.

43. Alexander Kinglake, *Eothen or Traces of Travel brought Home from the East* (Oxford and New York: Oxford University Press, 1982), 145. First published in 1845, *Eothen* is a refreshingly candid account of young Kinglake's travels.

44. Bergheim, the local photographer who had contributed three photographs for the survey publication, had a commercial studio in the city and thus could have provided the engineers with printing facilities.

45. *Diaries of Sir Moses and Lady Montefiore,* ed. Dr. L. Loewe, vol. 2 (Chicago: Belford-Clarke Co., 1890), 166. Loewe paraphrases many of the entries thus creating an odd first person/third person shift in the narrative.

46. In fact, at the end of the survey, Wilson reported himself to be out of pocket £300.

47. *Diaries,* 166.

48. James, *Ordnance Survey of Jerusalem,* 8.

49. V. D. Lipman, "The Origins of the Palestine Exploration Fund," in *Palestine Exploration Quarterly* no. 120, (1988): 51.

50. James, *Ordnance Survey of Jerusalem,* 12.

51. For a detailed narrative of circumstances surrounding the founding of the PEF and the role played by James and Grove, see Lipman, "The Origins of the Palestine Exploration Fund," 45–54.

52. Quoted in Lipman, "The Origins of the Palestine Exploration Fund," 45.

53. Both officers published personal accounts of their explorations: Charles Warren, *Underground Jerusalem* (1876); Charles Wilson, *Picturesque Palestine, Sinai, Egypt* (1880); together they published *The Recovery of Jerusalem* (1871), with a preface by Dean Stanley.

54. Neil Silberman, *Digging for God and Country: Exploration, Archeology, and the Secret Struggle for the Holy Land, 1799–1917* (New York: Alfred E. Knopf, 1982), is an engaging account of the dual British project of exploration and military intelligence.

55. Biographical material is taken from entries in the British Biographical Archive. Kitchener's role in Lawrence's photographic assignment is described by Rupert L. Chapman III and Shimon Gibson, "A Note on T.E. Lawrence as Photographer in the Wilderness of Zin," in *Palestine Exploration Quarterly,* no. 128 (1996): 15.

56. Sir Walter Besant, *Autobiography of Sir Walter Besant* (New York: Dodd, Mead and Co., 1902), 157–158.

57. All quotations in this section are taken from Besant's rueful catalogue of cranks in his *Autobiography,* 158–160.

58. George Williams, "Introduction," in *Ordnance Survey of the Peninsula of Sinai* (London: Lords Commissioners of Her Majesty's Treasury, 1871), 8.

59. Major General Sir Henry James, *Ordnance Survey of the Peninsula of Sinai,* 3.

60. Captain H. S. Palmer, "Account of the Surveys," in *Ordnance Survey of the Peninsula of Sinai,* 37.

61. Palmer, "Account of the Surveys," 52.

62. For a consideration of how various ideologies shape the practice of landscape photography, see Estell Jussim and Elizabeth Lindquist-Cock, *Landscape as Photograph* (New Haven: Yale University Press, 1985). *Landscape and Power,* ed. W.J.T. Mitchell (Chicago: University of Chicago Press, 1994) is a collection of essays that explores how the practice of presenting and picturing the landscape functions in a political/colonial context; see especially Joel Snyder, "Territorial Photography."

63. For a discussion of Sergeant McDonald's photographs that explores the connections between imperialism, geography and photography, see Howe, "The Collodion Map: The Photographic Surveys of the Royal Engineers in Palestine, 1864–1868," in *Picturing Place: Photography and the Construction of Imaginative Geographies,* eds. James R. Ryan and Joan Schwartz (New York: John Wiley and Sons, in press).

PLATES

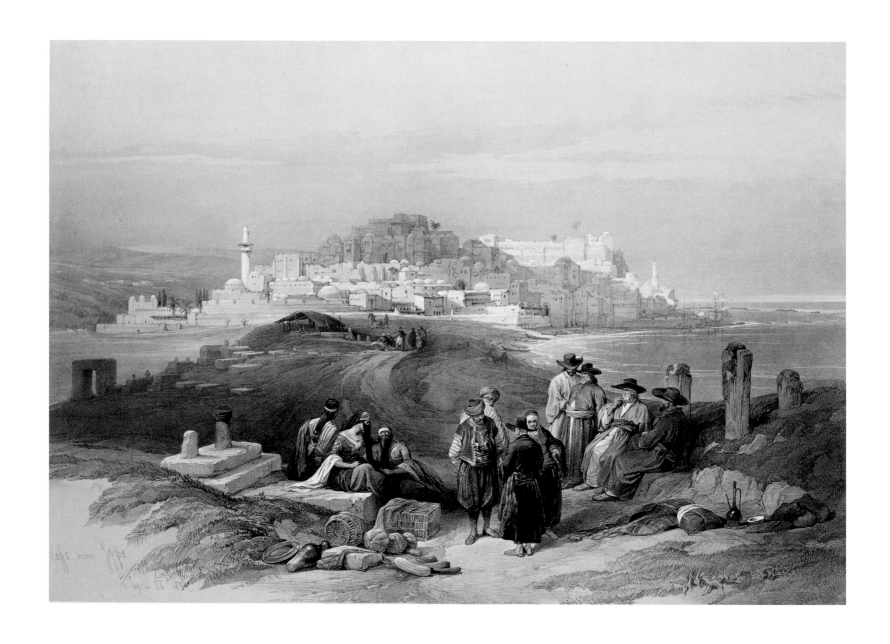

David Roberts
Scottish (1796–1864)
Jaffa Looking South, 1839
From the album *The Holy Land: Syria, Idumea, Arabia, Egypt and Nubia*
The Reverend George Croly, L.L.D., vol. 2 (London: 1843)
Lithograph by Louis Haghe after original drawing, 13 3/4 x 19 1/2 inches
Zimmerman Library, University of New Mexico, Albuquerque

Joseph-Philibert Girault de Prangey
French (1804–1892)
Temple of Jupiter, 1843
Daguerreotype, 5 3/4 x 3 3/4 inches
Gernsheim Collection, Harry Ransom Humanities Research Center
University of Texas at Austin

Maxime Du Camp
French (1822–1894)
Jerusalem, Mosque of Omar, 1850
Salted paper print, 6 1/2 x 8 3/4 inches
Michael and Jane Wilson Collection

Maxime Du Camp
French (1822–1894)
Jerusalem, Eastern Quarter, 1850
Salted paper print, 6 1/8 x 8 7/8 inches
Michael and Jane Wilson Collection

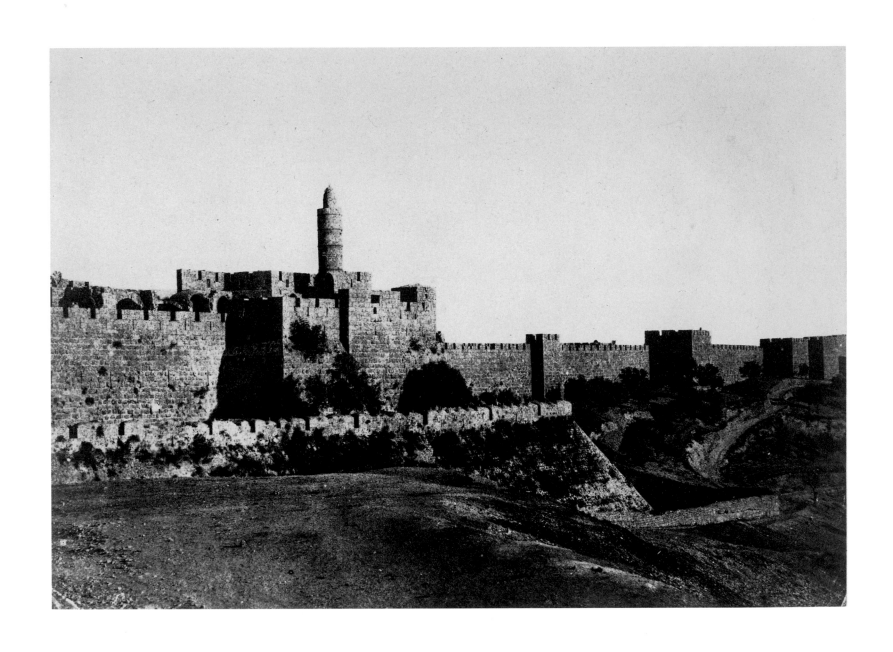

Maxime Du Camp
French (1822–1894)
Jerusalem, Western Section of the City Walls, 1850
Salted paper print, 6 1/8 x 8 1/2 inches
Michael and Jane Wilson Collection

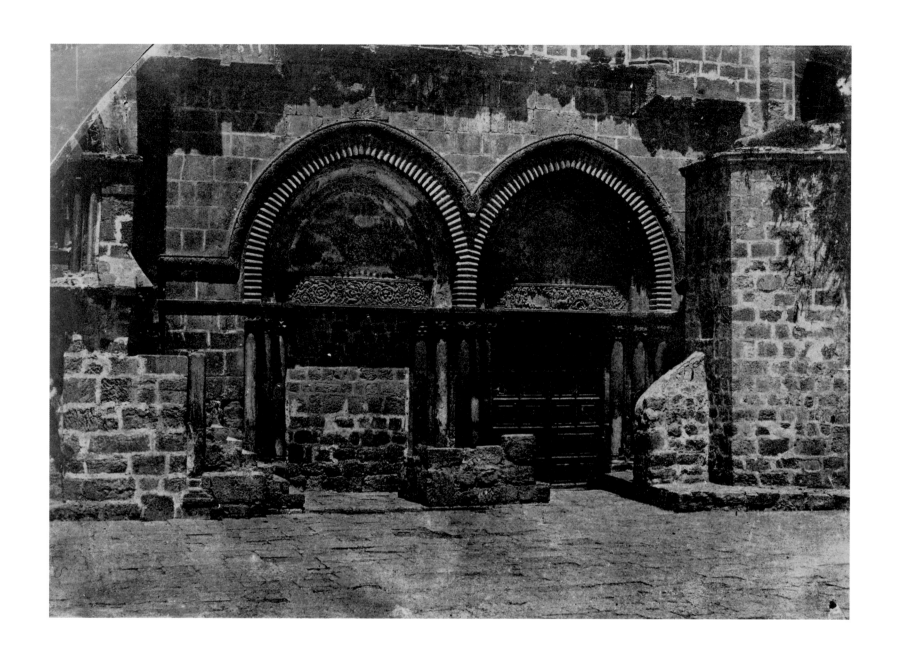

Maxime Du Camp
French (1822–1894)
Jerusalem, Interior Arcades of the Church of Saint Sepulchre, 1850
Salted paper print, 6 5/8 x 9 1/4 inches
Michael and Jane Wilson Collection

The Reverend George W. Bridges
English (active c. 1846–1852)
Jerusalem, Saint Mark's House, 1850
Salted paper print, 6 5/8 x 8 1/2 inches
Michael and Jane Wilson Collection

Ernest Benecke
German (active 1851–1858)
View of Herod's Palace, House of David, 1852
From *Syrie et Terre Sainte*
Salted paper print, 6 $\frac{1}{2}$ x 8 $\frac{1}{4}$ inches
Michael and Jane Wilson Collection

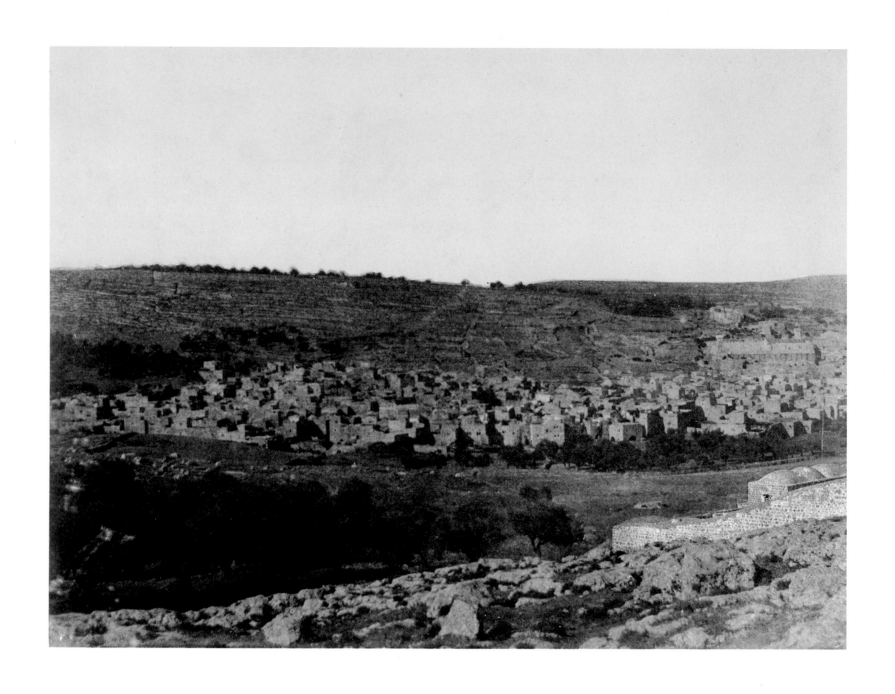

Ernest Benecke
German (active 1851–1858)
Hebron, A Frieze of the Quarantine, 1852
Salted paper print, 6 $^{3}/_{8}$ x 8 $^{3}/_{8}$ inches
Michael and Jane Wilson Collection

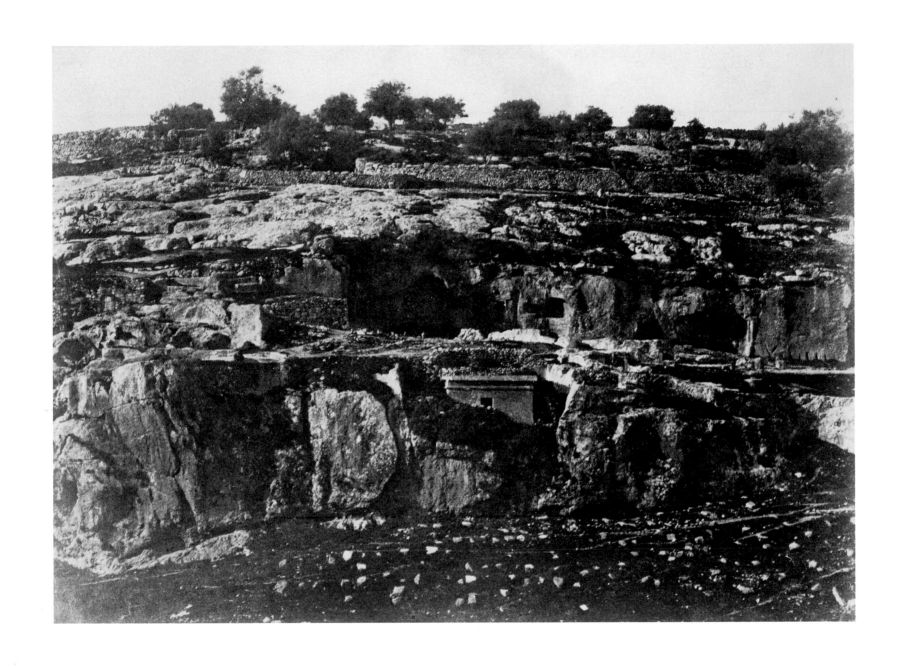

Auguste Salzmann
German (1824–1872)
Village of Siloam, 1854
Salted paper print, 9 1/4 x 12 3/4 inches
Michael and Jane Wilson Collection

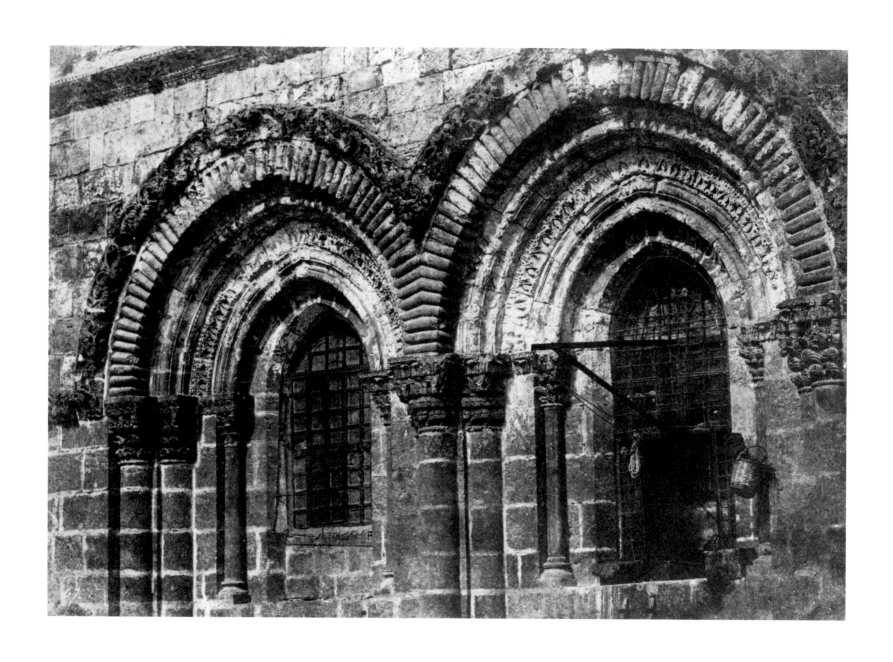

Auguste Salzmann
German (1824–1872)
Jerusalem, Saint Sepulchre, 1854
Salted paper print, 9 x 12 $^{7}/_{8}$ inches
Michael and Jane Wilson Collection

Auguste Salzmann
German (1824–1872)
Saint Sepulchre, 1854
Salted paper print, 13 1/8 x 9 inches
Michael and Jane Wilson Collection

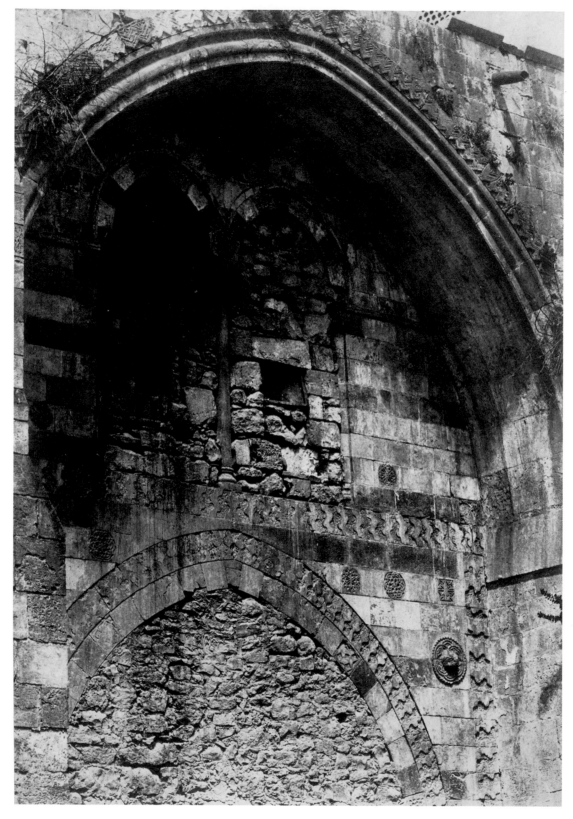

Auguste Salzmann
German (1824–1872)
Principal Entrance, Palace of the Kings of Jerusalem, 1854
Salted paper print, 13 x 9 1/8 inches
Michael and Jane Wilson Collection

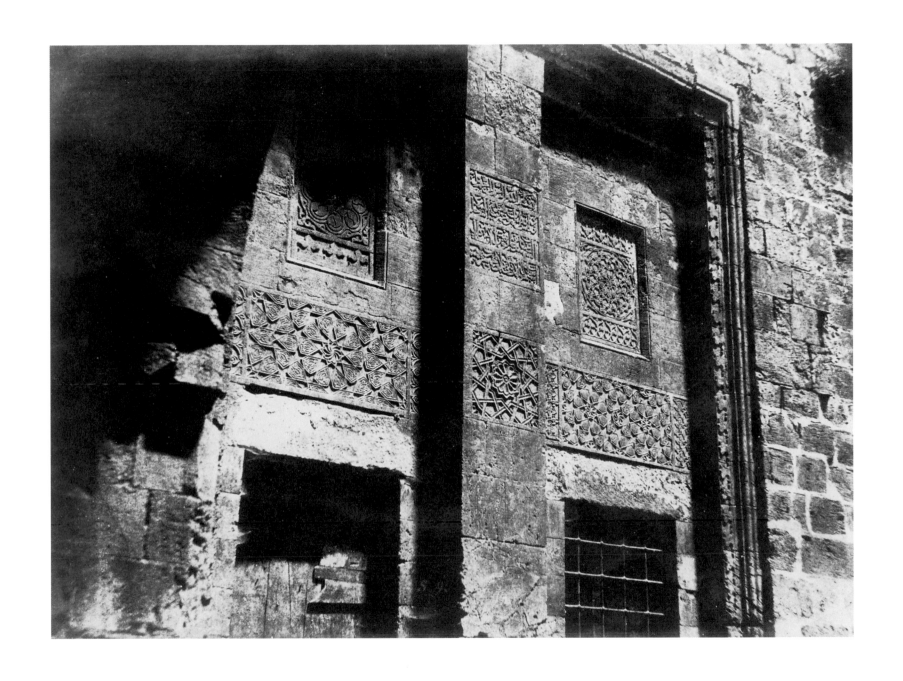

Auguste Salzmann
German (1824–1872)
Jerusalem, Arabic Ornamentation, 1854
Salted paper print, 9 1/4 x 12 3/4 inches
Collection of Marjorie and Leonard Vernon

Auguste Salzmann
German (1824–1872)
Jerusalem, Fountain of the Greek Convent, 1854
Salted paper print, 9 1/8 x 12 5/8 inches
Michael and Jane Wilson Collection

Auguste Salzmann
German (1824–1872)
Mosque of Omar, West Section of Interior of the Enclosure, 1854
Salted paper print, 8 7/8 x 12 7/8 inches
Michael and Jane Wilson Collection

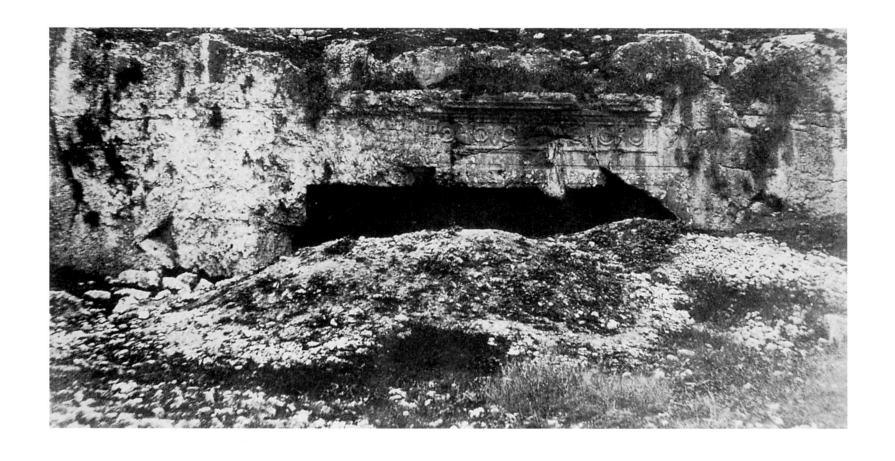

Auguste Salzmann
German (1824–1872)
Jerusalem, Tomb of the Kings of Judah, 1854
Salted paper print, 9 3/8 x 13 1/4 inches
Michael and Jane Wilson Collection

Auguste Salzmann
German (1824–1872)
Jewish Sarcophagus, 1854
Salted paper print, 9 x 13 inches
Michael and Jane Wilson Collection

Auguste Salzmann
German (1824–1872)
Helmet Found in Jordan, 1854
Salted paper print, 9 1/8 x 13 inches
Collection of Marjorie and Leonard Vernon

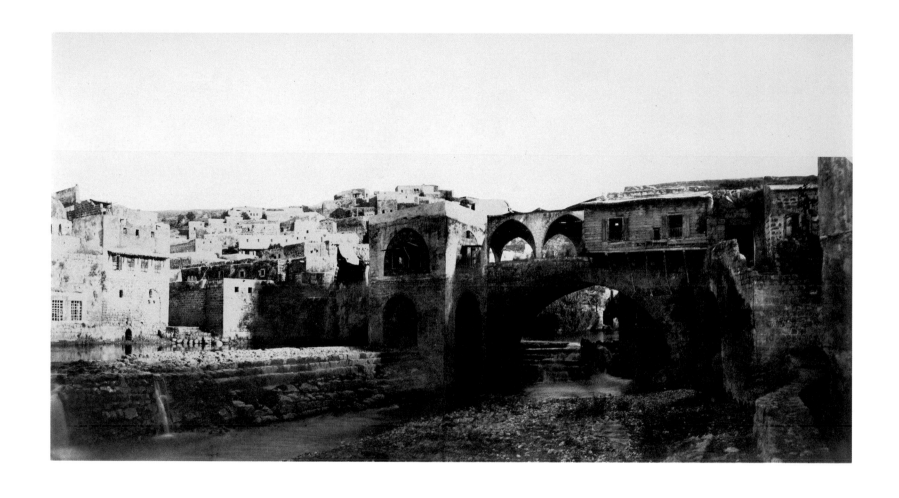

Louis De Clercq
French (1836–1901)
Tripoli, 1859–1860
From *Voyages en Orient*, Album 1: *Picturesque View of the Cities and Monuments of Syria*
Albumen print, 8 5/8 x 22 inches
Michael and Jane Wilson Collection

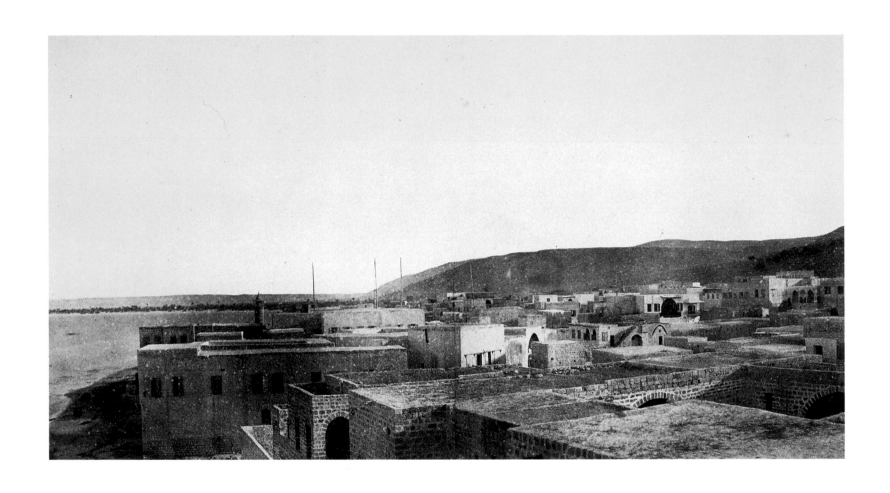

Louis De Clercq
French (1836–1901)
Kaifa, 1859–1860
From *Voyages en Orient*, Album 1: *Picturesque View of the Cities and Monuments of Syria*
Albumen print, 8 1/2 x 21 5/8 inches
Collection of Michael Mattis and Judith Hochberg

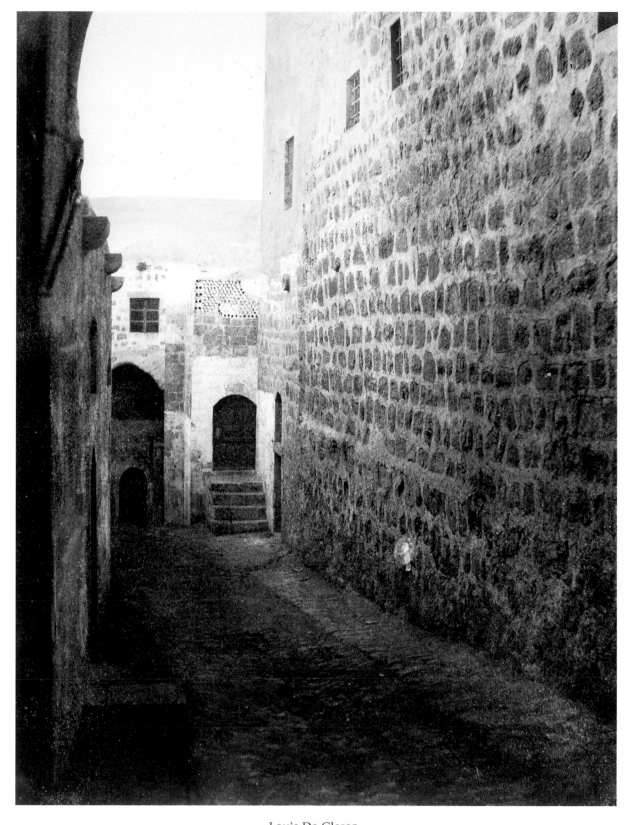

Louis De Clercq
French (1836–1901)
Eighth Station of the Cross, 1859–1860
From *Voyages en Orient*, Album 4: *Les Stations de la Voie Douloureuse á Jerusalem* (The Stations of the Cross)
Albumen print, 11 1/$_4$ x 8 5/$_8$ inches
Collection of Canadian Centre for Architecture

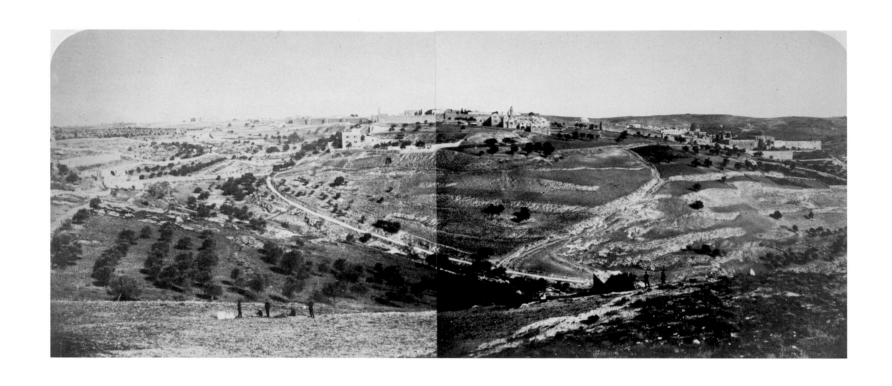

Sergeant James McDonald
English (1822–1885)
Panoramic View of the City, General View of the City from the Hill of the Evil Counsel, 1864
From *Ordnance Survey of Jerusalem, Photographs*
Albumen print, 7 3/4 x 18 5/8 inches
Michael and Jane Wilson Collection

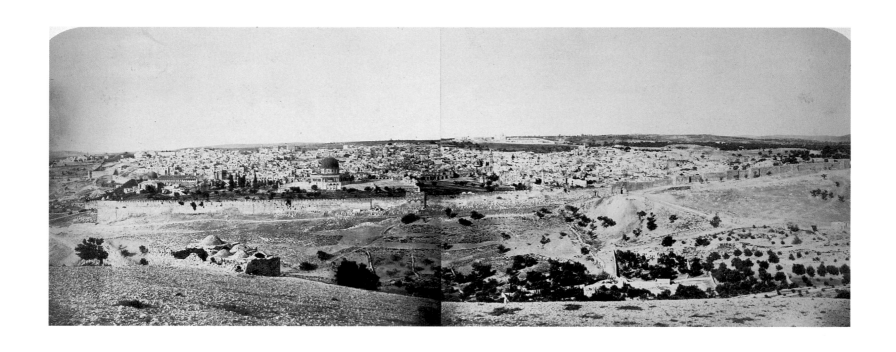

Sergeant James McDonald
English (1822–1885)
Panoramic View of the City, General View of the City from the Mount of Olives, 1864
From *Ordnance Survey of Jerusalem, Photographs*
Albumen print, 7 3/4 x 18 5/8 inches
Michael and Jane Wilson Collection

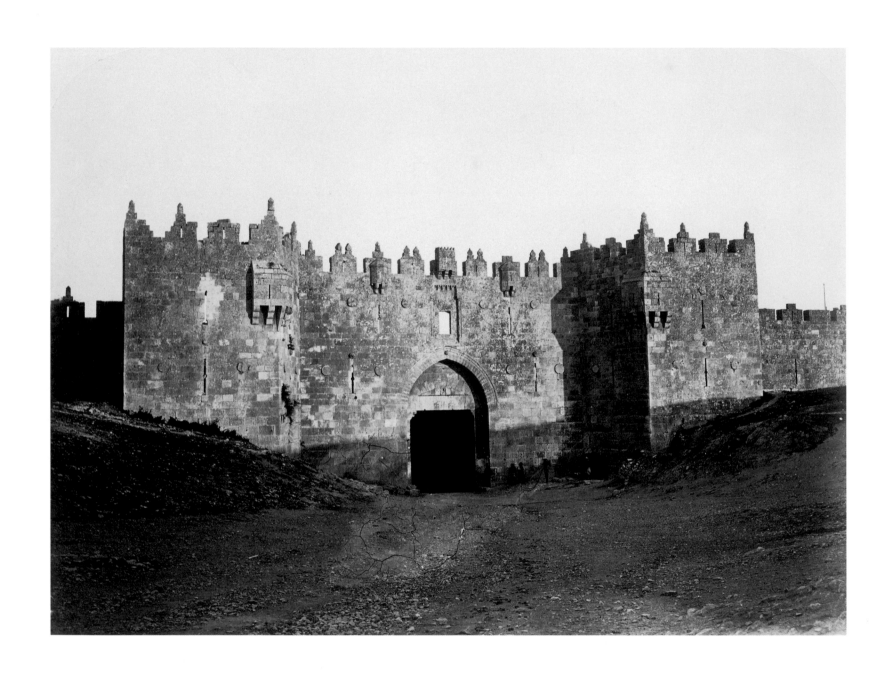

Sergeant James McDonald
English (1822–1885)
*Damascus Gate,*1864
From *Photographs of Jerusalem*
Albumen print, 6 3/8 x 8 5/8 inches
Michael and Jane Wilson Collection

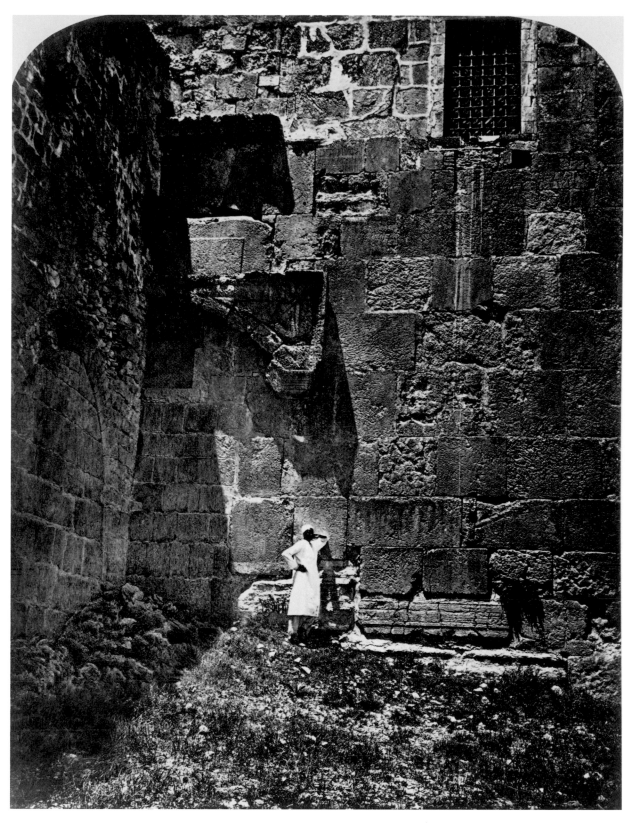

Sergeant James McDonald
English (1822–1885)
Double Gateway in South Wall, 1864
From *Photographs of Jerusalem*
Albumen print, 8 $^1/_4$ x 6 $^1/_4$ inches
Michael and Jane Wilson Collection

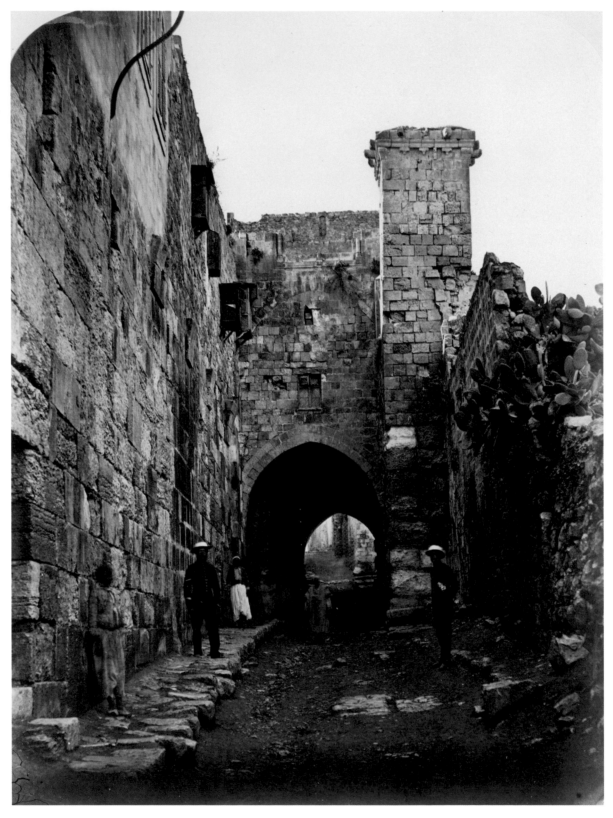

Sergeant James McDonald
English (1822–1885)
The So-Called Tower of Antonia in the Street leading to Saint Stephen's Church, 1864
From *Photographs of Jerusalem*
Albumen print, 9 5/8 x 7 3/8 inches
Michael and Jane Wilson Collection

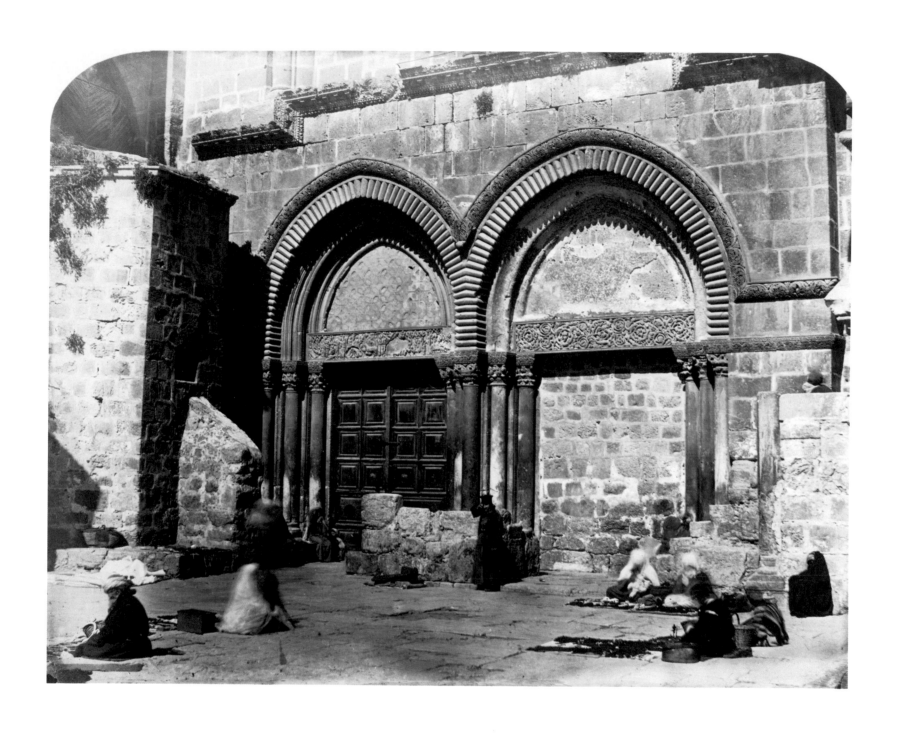

Sergeant James McDonald
English (1822–1885)
Entrance to the Church of the Holy Sepulchre, 1864
From *Photographs of Jerusalem*
Albumen print, 7 3/4 x 9 3/4 inches
Michael and Jane Wilson Collection

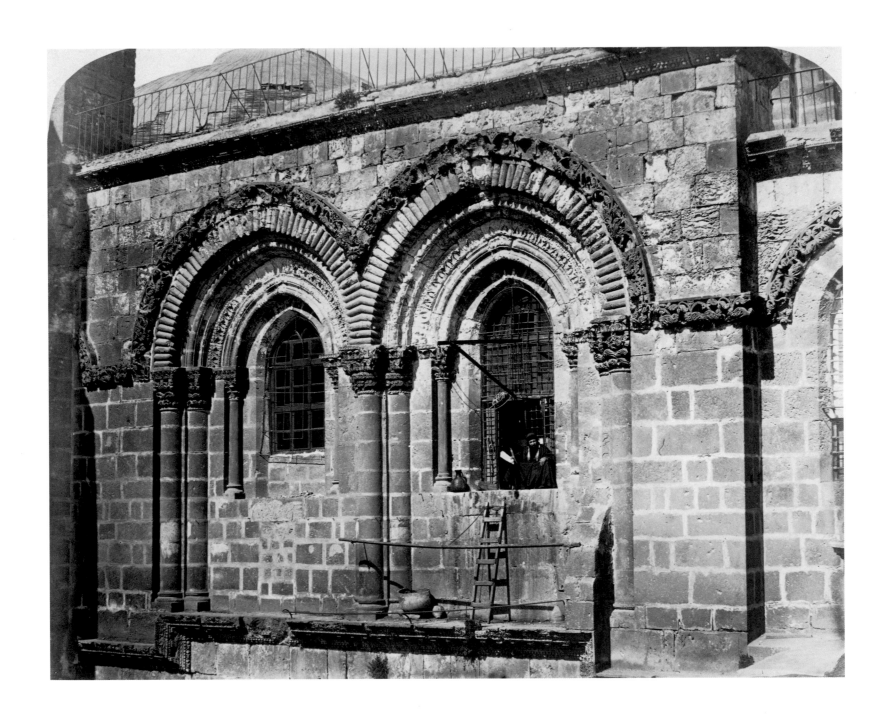

Sergeant James McDonald
English (1822–1885)
Window in the South Face of the Church of the Holy Sepulchre, 1864
From *Photographs of Jerusalem*
Albumen print, 7 3/4 x 9 5/8 inches
Michael and Jane Wilson Collection

Sergeant James McDonald
English (1822–1885)
West Wall and Cloister Looking South, 1864
From *Photographs of Jerusalem*
Albumen print, 6 3/4 x 8 5/8 inches
Michael and Jane Wilson Collection

Sergeant James McDonald
English (1822–1885)
Entrance to Hospital of the Knights of Saint John, 1864
From *Photographs of Jerusalem*
Albumen print, 6 7/8 x 8 1/2 inches
Michael and Jane Wilson Collection

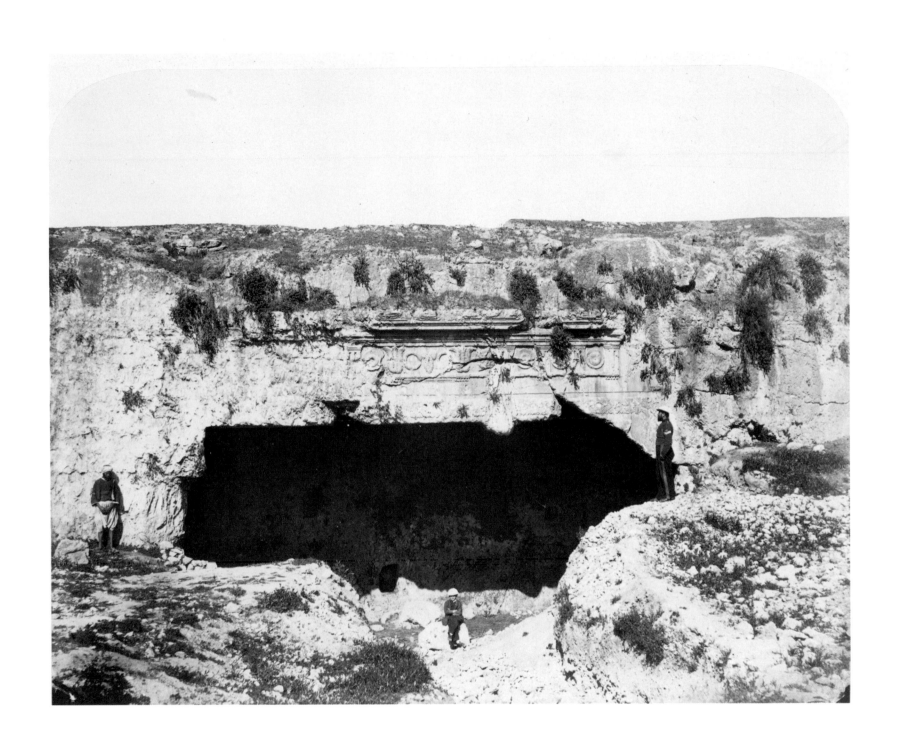

Sergeant James McDonald
English (1822–1885)
Entrance to the Tombs of the Kings, 1864
From *Photographs of Jerusalem*
Albumen print, 7 ³/₄ x 9 ³/₄ inches
Michael and Jane Wilson Collection

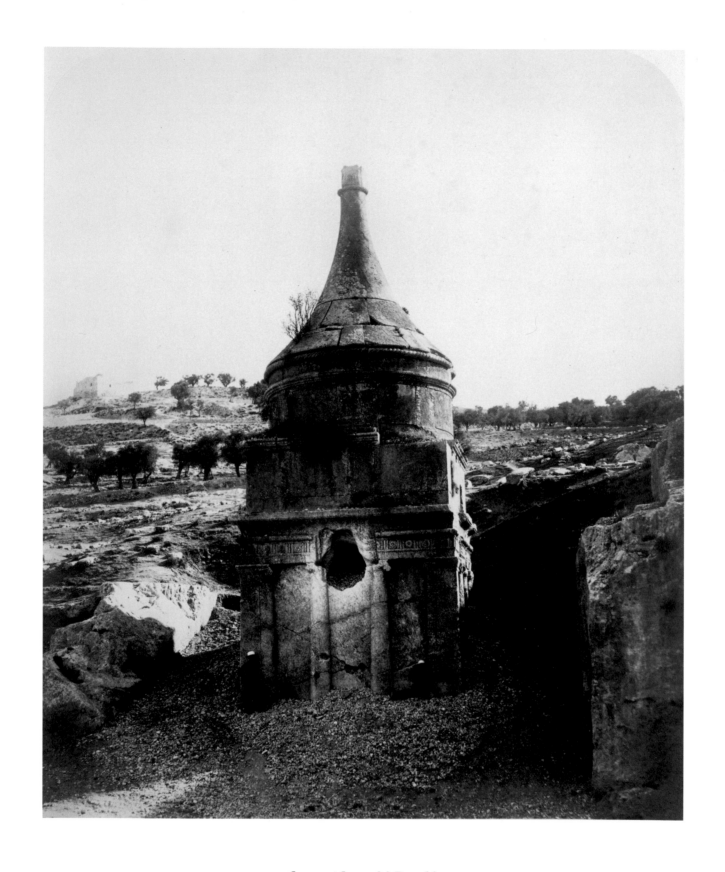

Sergeant James McDonald
English (1822–1885)
Tomb of Absalom, 1864
From *Photographs of Jerusalem*
Albumen print, 10 x 8 1/4 inches
Michael and Jane Wilson Collection

Sergeant James McDonald
English (1822–1885)
Entering the Desert by Ayún Músa (Wells of Moses), 1868–1869
From *Ordnance Survey of the Peninsula of Sinai*, Part III: *Photographs*, Volume 1
Albumen print, 6 $^5/_8$ x 8 $^1/_2$ inches
Michael and Jane Wilson Collection

Sergeant James McDonald
English (1822–1885)
Moses' Well, Jebel Músá, 1868–1869
From *Ordnance Survey of the Peninsula of Sinai*, Part III: *Photographs*, Volume 1
Albumen print, 6 $^5/_8$ x 8 $^1/_2$ inches
Michael and Jane Wilson Collection

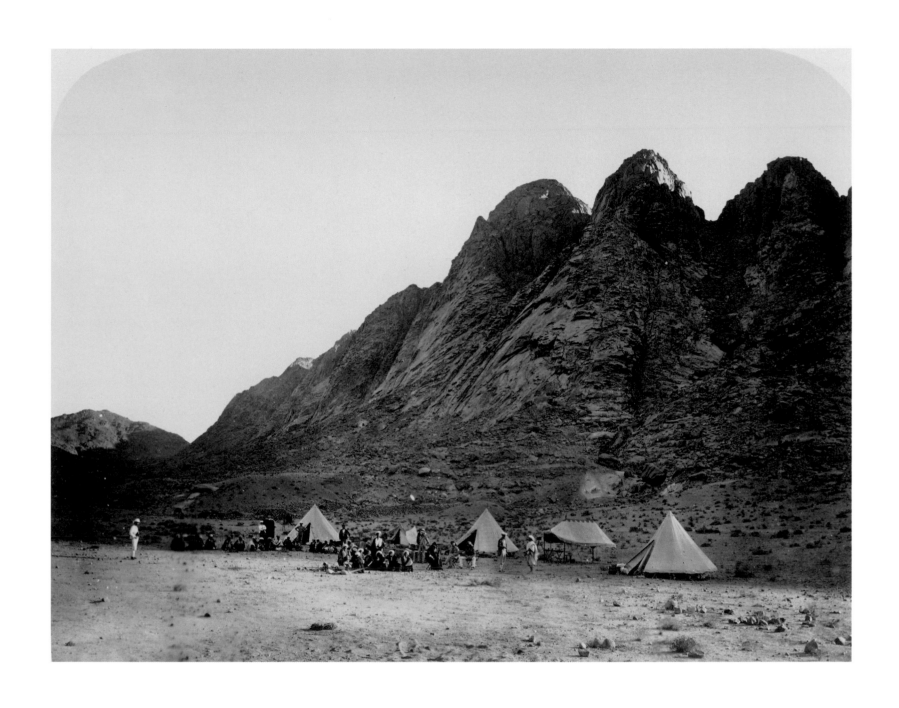

Sergeant James McDonald
English (1822–1885)
Camp in Wady ed Deir, 1868–1869
From *Ordnance Survey of the Peninsula of Sinai,* Part III: *Photographs,* Volume 1
Albumen print, 6 5/8 x 25 5/8 inches
Michael and Jane Wilson Collection

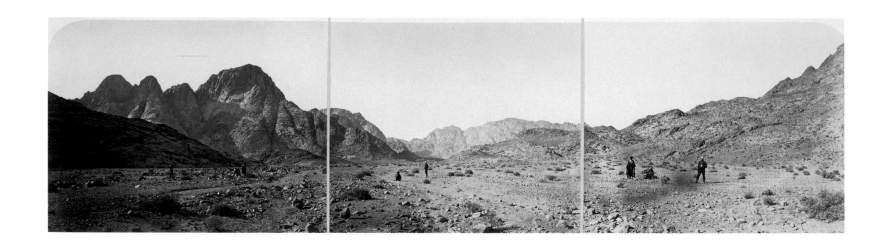

Sergeant James McDonald
English (1822–1885)
Rás Sufsáfeh from Wády ed Deir, 1868–1869
From *Ordnance Survey of the Peninsula of Sinai*, Part III: *Photographs*, Volume 1
Albumen print, 6 $\frac{5}{8}$ x 25 $\frac{5}{8}$ inches
Michael and Jane Wilson Collection

Sergeant James McDonald
English (1822–1885)
Wady Feiran, with Mouth of Wady Aleyat, 1868–1869
From *Ordnance Survey of the Peninsula of Sinai,* Part III: *Photographs,* Volume 2
Albumen print, 6 $^5/_8$ x 8 $^1/_2$ inches
Michael and Jane Wilson Collection

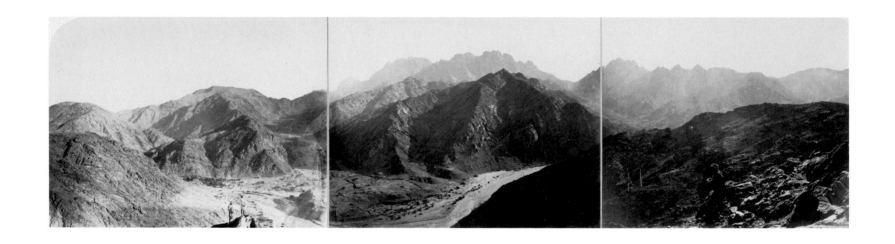

Sergeant James McDonald
English (1822–1885)
Jebel Serbal from Jebel Tahuneh, 1868–1869
From *Ordnance Survey of the Peninsula of Sinai,* Part III: *Photographs,* Volume 2
Albumen print, 6 $^5/_8$ x 8 $^1/_2$ inches
Michael and Jane Wilson Collection

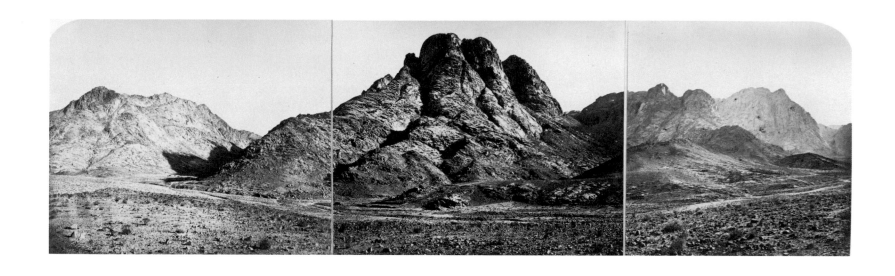

Sergeant James McDonald
English (1822–1885)
Mount Sinai from the South end of Base on Ujret el Mehd, 1868–1869
From *Ordnance Survey of the Peninsula of Sinai,* Part III: *Photographs,* Volume 1
Albumen print, 6 $^5/8$ x 25 $^5/8$ inches
Michael and Jane Wilson Collection

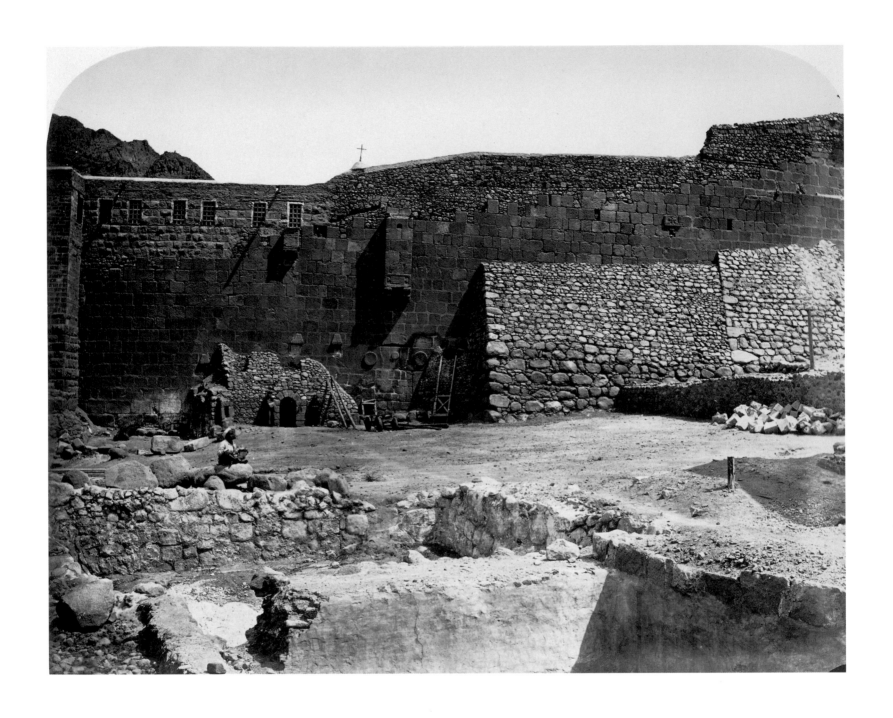

Sergeant James McDonald
English (1822–1885)
North Wall of Convent, Showing Entrance, 1868–1869
From *Ordnance Survey of the Peninsula of Sinai*, Part III: *Photographs*, Volume 1
Albumen print, 6 5/8 x 25 5/8 inches
Michael and Jane Wilson Collection

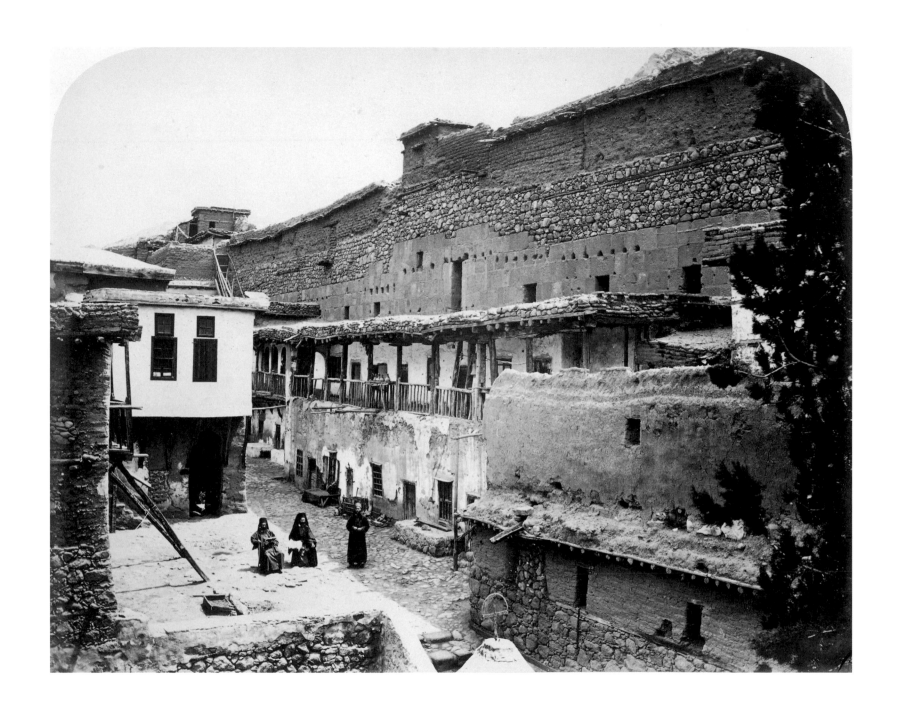

Sergeant James McDonald
English (1822–1885)
Interior of Convent of Saint Catherine, West Wall, 1868–1869
From *Ordnance Survey of the Peninsula of Sinai*, Part III: *Photographs*, Volume 1
Albumen print, 6 5/$_8$ x 8 1/$_2$ inches
Michael and Jane Wilson Collection

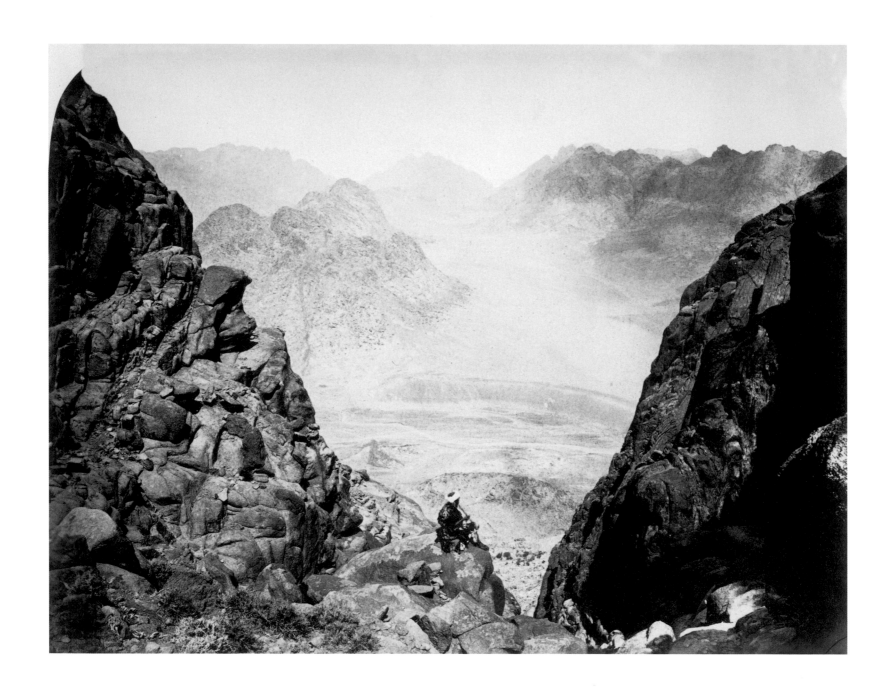

Sergeant James McDonald
English (1822–1885)
Plain of Er Ráhah from the Cleft on Rás Sufsáfeh, 1868–1869
From *Ordnance Survey of the Peninsula of Sinai,* Part III: *Photographs,* Volume 1
Albumen print, 6 $^5/_8$ x 8 $^1/_2$ inches
Michael and Jane Wilson Collection

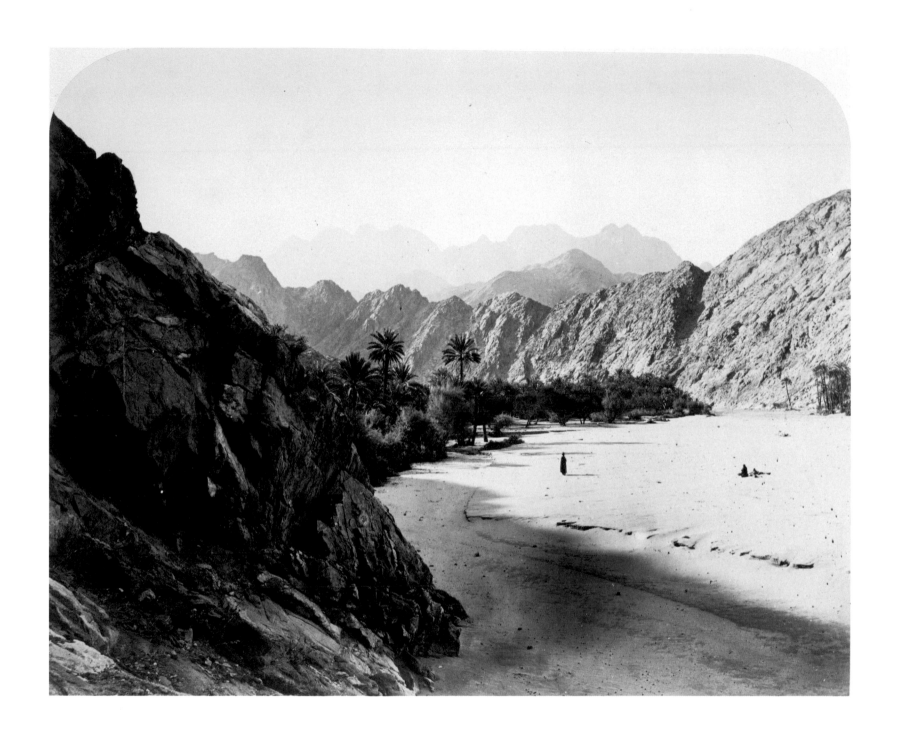

Sergeant James McDonald
English (1822–1885)
Distant View of Jebel Serbal, from the Palm Grove, Wady Feiran, 1868–1869
From *Ordnance Survey of the Peninsula of Sinai*, Part III: *Photographs*, Volume 2
Albumen print, 6 5/8 x 8 1/2 inches
Michael and Jane Wilson Collection

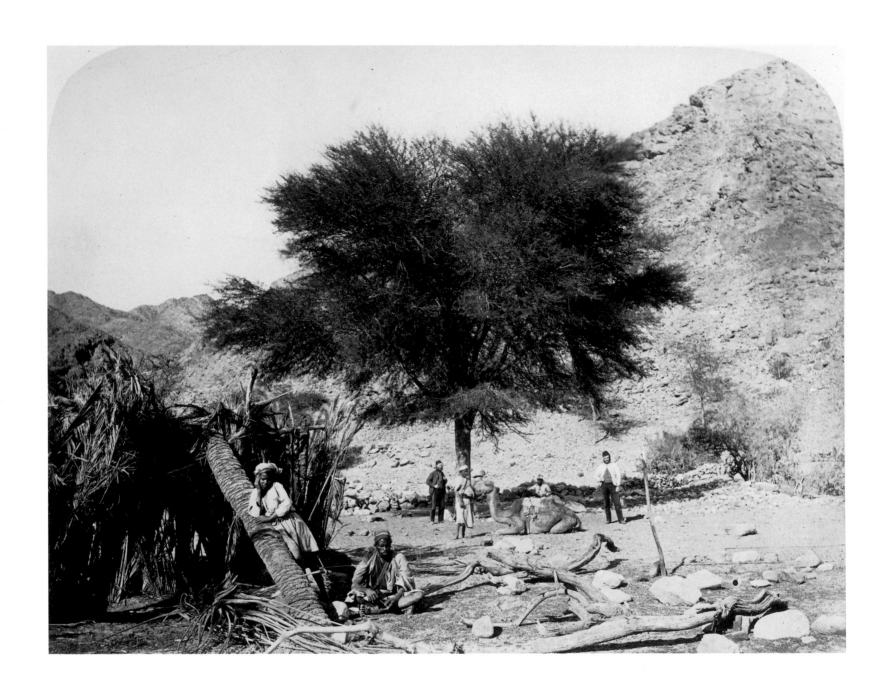

Sergeant James McDonald
English (1822–1885)
Seyal (Shittim) Tree, Dedicated to the Patron Saint, Wady Feiran, 1868–1869
From *Ordnance Survey of the Peninsula of Sinai,* Part III: *Photographs,* Volume 2
Albumen print, 6 $^1/_2$ x 8 $^3/_8$ inches
Michael and Jane Wilson Collection

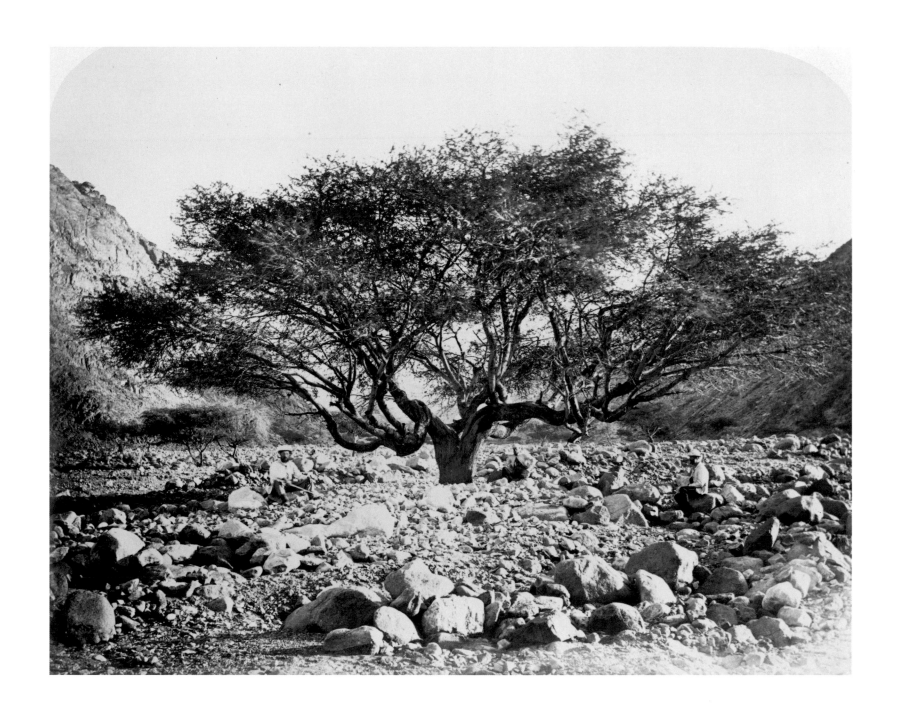

Sergeant James McDonald
English (1822–1885)
Seyal (Shittim) Tree, Mouth of Wady Aleyat, 1868–1869
From *Ordnance Survey of the Peninsula of Sinai*, Part III: *Photographs*, Volume 2
Albumen print, 6 ⁵/₈ x 8 ¹/₂ inches
Michael and Jane Wilson Collection

Sergeant James McDonald
English (1822–1885)
Wady Aleyát, with Inscribed Stones, 1868–1869
From *Ordnance Survey of the Peninsula of Sinai,* Part III: *Photographs,* Volume 3
Albumen print, 6 $^5/_8$ x 8 $^1/_2$ inches
Michael and Jane Wilson Collection

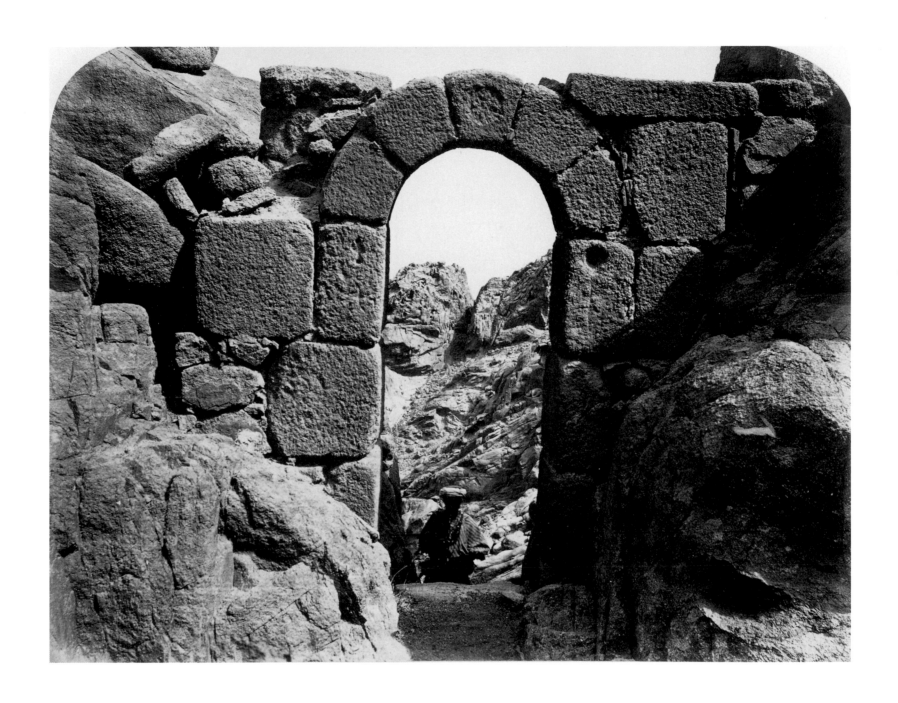

Sergeant James McDonald
English (1822–1885)
Archway on the Ascent to Jebel Músá at Which Pilgrims Were Formerly Confessed, 1868–1869
From *Ordnance Survey of the Peninsula of Sinai*, Part III: *Photographs*, Volume 1
Albumen print, 6 5/8 x 8 1/2 inches
Michael and Jane Wilson Collection

Sergeant James McDonald
English (1822–1885)
The Cypress, Jebel Músá, 1868–1869
From *Ordnance Survey of the Peninsula of Sinai*, Part III: *Photographs*, Volume 1
Albumen print, 6 $^5/_8$ x 8 $^1/_2$ inches
Michael and Jane Wilson Collection

Sergeant James McDonald
English (1822–1885)
Rocks in Wady Nakhleh, 1868–1869
From *Ordnance Survey of the Peninsula of Sinai*, Part III: *Photographs*, Volume 2
Albumen print, 6 $^5/_8$ x 8 $^1/_2$ inches
Michael and Jane Wilson Collection

Sergeant James McDonald
English (1822–1885)
Stele, Serábit El Khádim, 1868–1869
From *Ordnance Survey of the Peninsula of Sinai*, Part III: *Photographs*, Volume 1
Albumen print, 6 5/8 x 8 1/2 inches
Michael and Jane Wilson Collection

Sergeant James McDonald
English (1822–1885)
Carved Stone from Ruined Convent in Wady Feiran, 1868–1869
From *Ordnance Survey of the Peninsula of Sinai*, Part III: *Photographs*, Volume 2
Albumen print, 6 ⁵/₈ x 8 ¹/₂ inches
Michael and Jane Wilson Collection

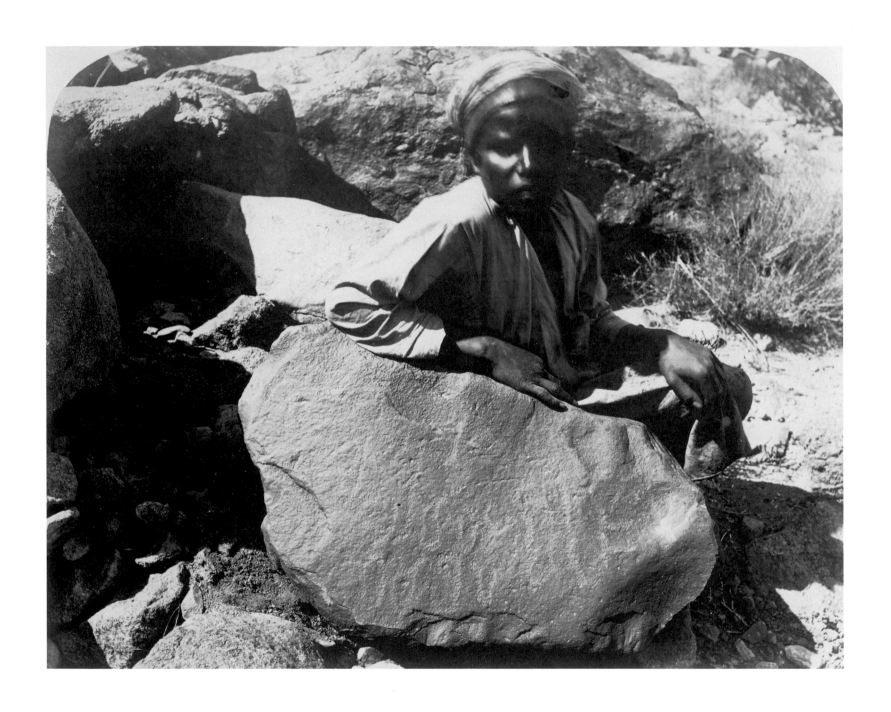

Sergeant James McDonald
English (1822–1885)
Inscription, Wady Ájeleh, 1868–1869
From *Ordnance Survey of the Peninsula of Sinai*, Part III: *Photographs*, Volume 3
Albumen print, 6 $^5/_8$ x 8 $^1/_2$ inches
Michael and Jane Wilson Collection

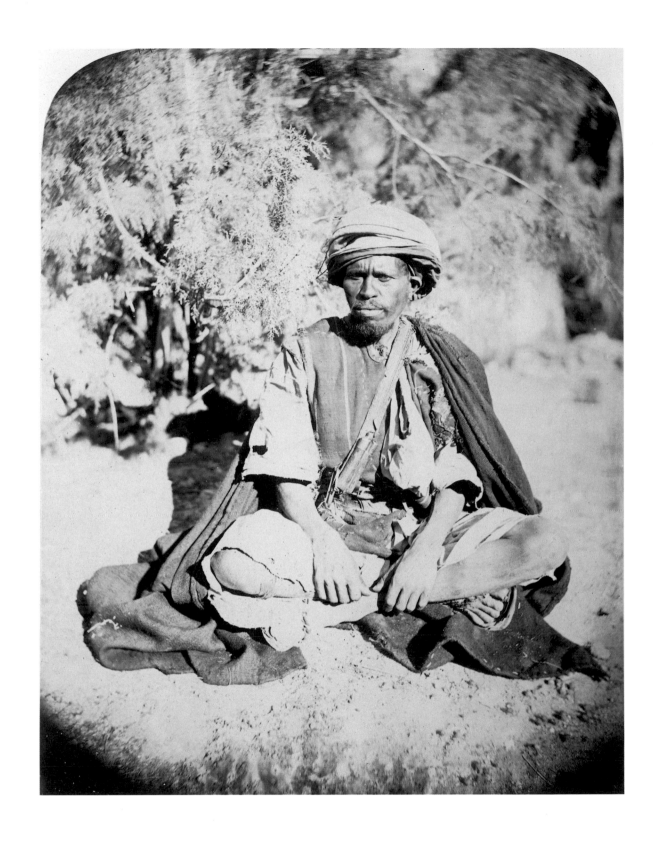

Sergeant James McDonald
English (1822–1885)
Hassan El Harbi, Guide to Jebel Serbal, 1868–1869
From *Ordnance Survey of the Peninsula of Sinai*, Part III: *Photographs*, Volume 2
Albumen print, 6 ⁵/8 x 8 ¹/2 inches
Michael and Jane Wilson Collection

Sergeant James McDonald
English (1822–1885)
Egyptian Tablet from the Mines of Wady Igná, 1868–1869
From *Ordnance Survey of the Peninsula of Sinai,* Part III: *Photographs,* Volume 3
Albumen print, 6 5/8 x 8 1/2 inches
Michael and Jane Wilson Collection

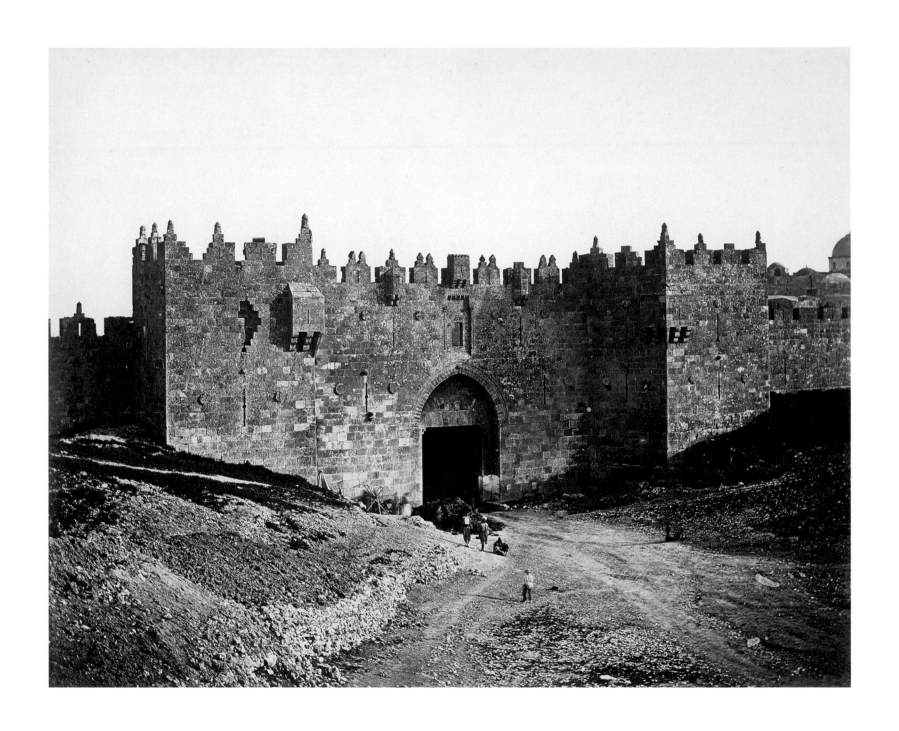

James Robertson & Felix Beato
English (c. 1813–1882)
Italian, naturalized English citizen (c. 1825–1903)
Damascus Gate, 1857
Albumen print, 10 $^3/_4$ x 12 inches
Michael and Jane Wilson Collection

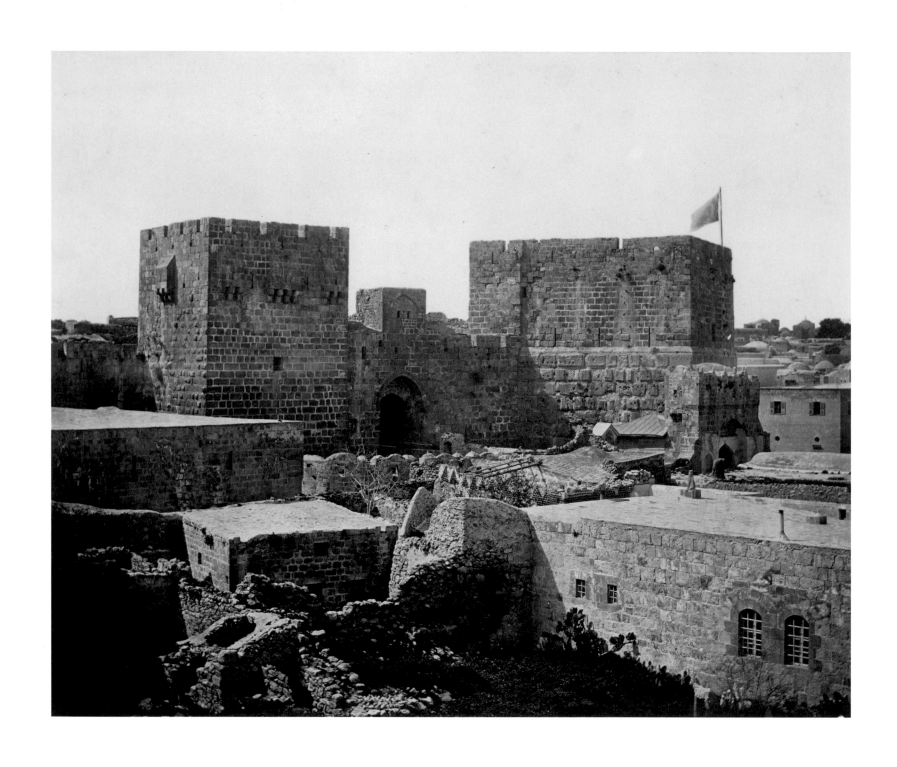

James Robertson & Felix Beato
English (c. 1813–1882)
Italian, naturalized English citizen (c. 1825–1903)
Jerusalem (Section of Old City), 1857
Albumen print, 10 1/$_4$ x 12 1/$_8$ inches
Michael and Jane Wilson Collection

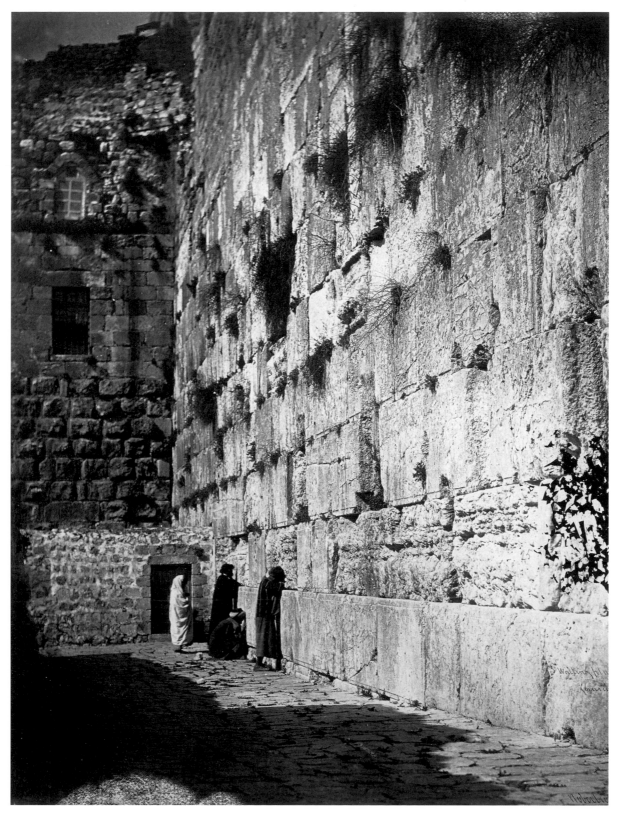

James Robertson & Felix Beato
English (c. 1813–1882)
Italian, naturalized English citizen (c. 1825–1903)
Wailing Place of the Jews, Jerusalem, 1857
Albumen print, 12 $^1/4$ x 9 $^1/8$ inches
Michael and Jane Wilson Collection

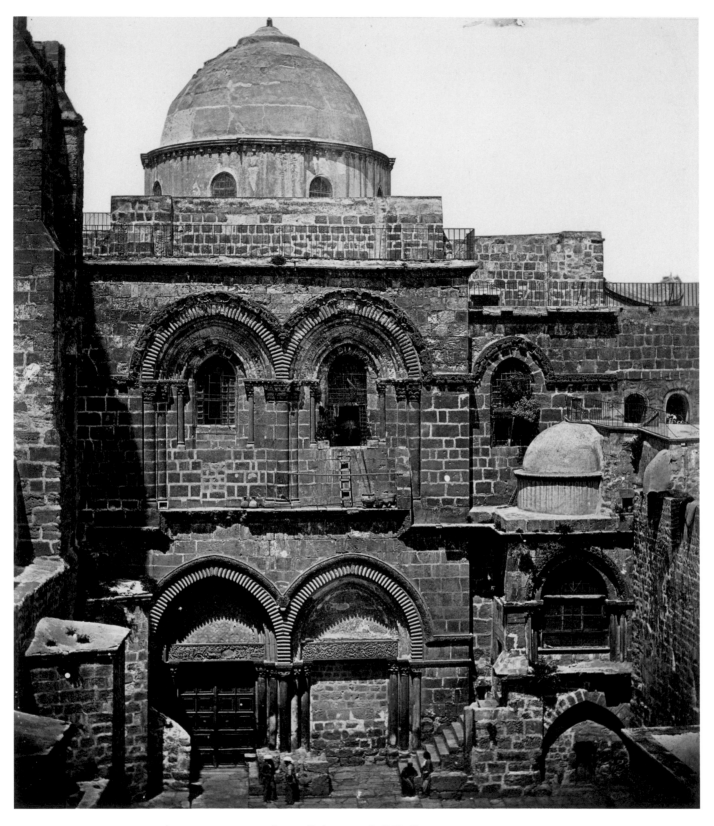

James Robertson & Felix Beato
English (c. 1813–1882)
Italian, naturalized English citizen (c. 1825–1903)
Church of the Holy Sepulchre, 1857
Albumen print, 12 $\frac{1}{4}$ x 10 $\frac{5}{8}$ inches
Michael and Jane Wilson Collection

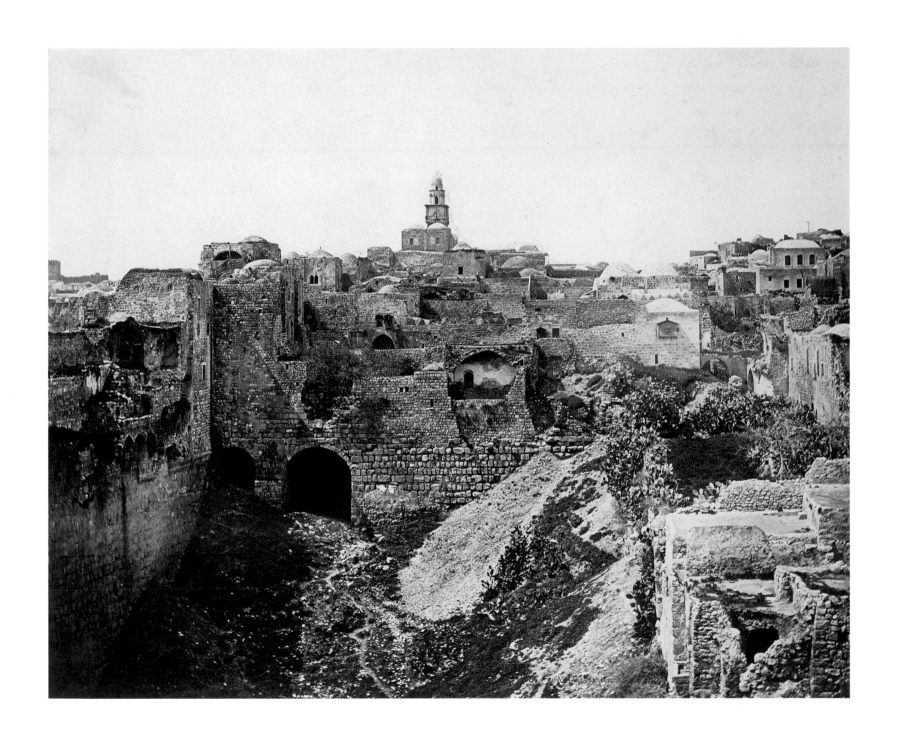

James Robertson & Felix Beato
English (c. 1813–1882)
Italian, naturalized English citizen (c. 1825–1903)
Pool of Bethesda, 1857
Albumen print, 10 x 12 ³/8 inches
Michael and Jane Wilson Collection

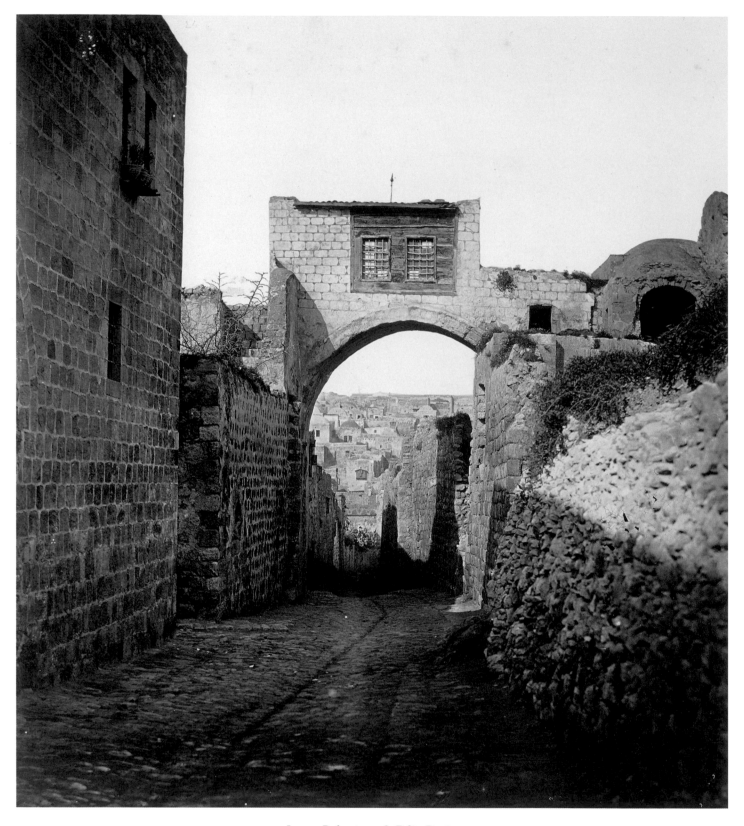

James Robertson & Felix Beato
English (c. 1813–1882)
Italian, naturalized English citizen (c. 1825–1903)
Ecce Homo Arch, 1857
Albumen print, 11 3/4 x 10 3/8 inches
Michael and Jane Wilson Collection

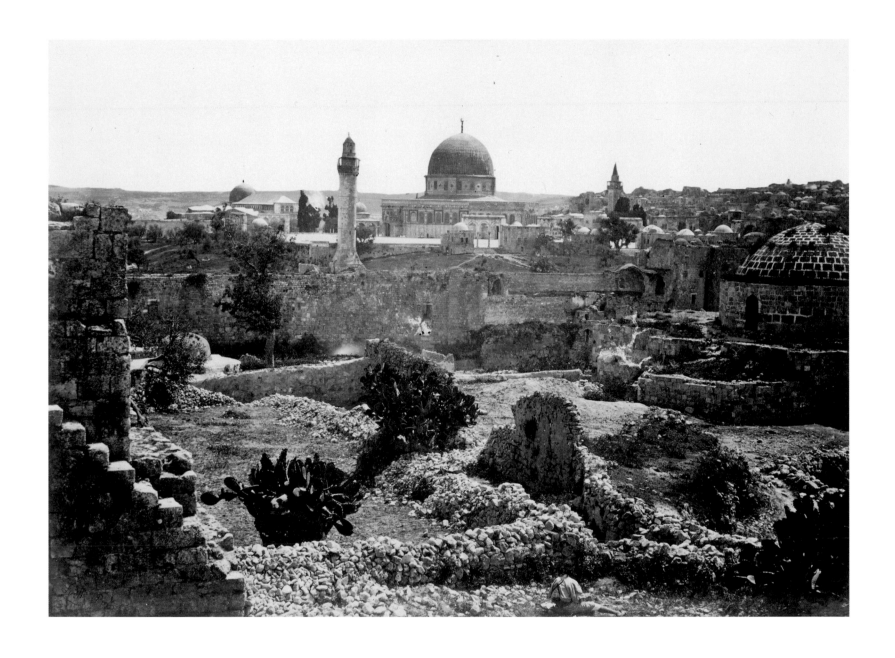

Francis Frith
English (1822–1898)
Jerusalem from the City Wall, 1857
From *Egypt, Sinai and Palestine,* by Francis Frith, supplementary volume, 1862
Albumen print, 6 1/4 x 8 3/4 inches
Michael and Jane Wilson Collection

Francis Frith
English (1822–1898)
Arab Sportsman and Cook, 1857
From *Egypt, Sinai, and Palestine*, by Francis Frith, supplementary volume, 1862
Albumen print, 8 3/4 x 6 1/4 inches
Michael and Jane Wilson Collection

Francis Frith
English (1822–1898)
Nazareth from the Northwest, 1857
From *Sinai and Palestine,* by Francis Frith, 1862
Albumen print, 6 1/4 x 9 inches
Michael and Jane Wilson Collection

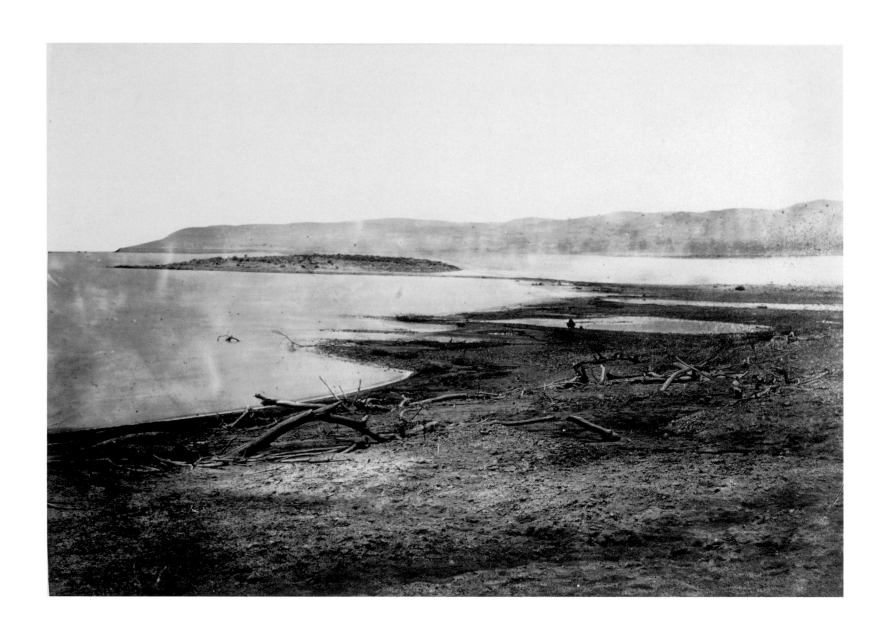

Francis Frith
English (1822–1898)
North Shore of the Dead Sea, 1857
From *Sinai and Palestine*, by Francis Frith, 1862
Albumen print, 6 3/8 x 9 inches
Michael and Jane Wilson Collection

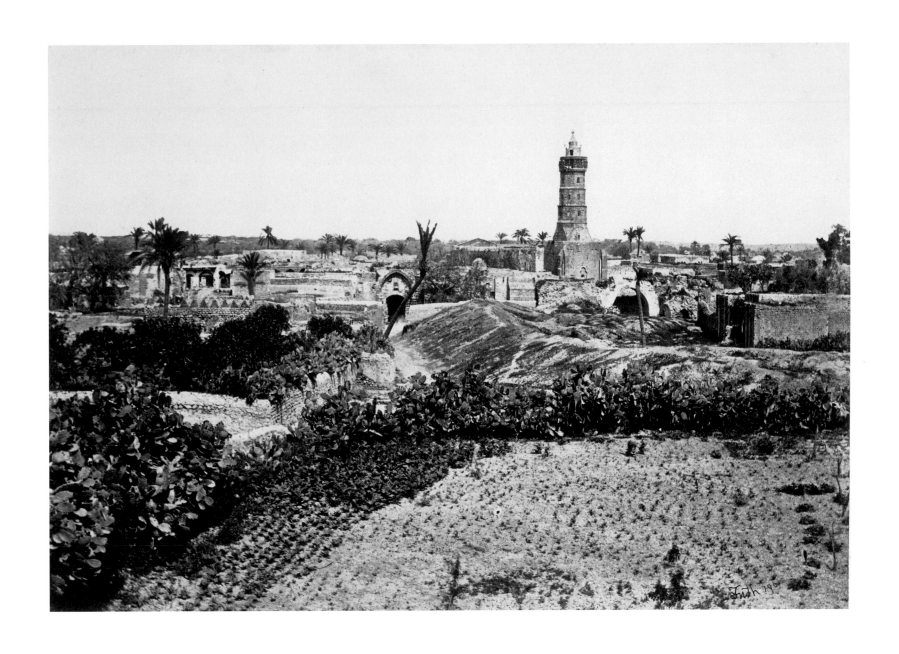

Francis Frith
English (1822–1898)
Gaza (The Old Town), c. 1858
From *Sinai and Palestine,* by Francis Frith, 1862
Albumen print, 6 3/8 x 9 inches
Michael and Jane Wilson Collection

Francis Frith
English (1822–1898)
Wady-L-Bachleh, 1857
From *Egypt, Sinai, and Palestine*, by Francis Frith, 1862
Albumen print, 6 1/4 x 9 inches
Michael and Jane Wilson Collection

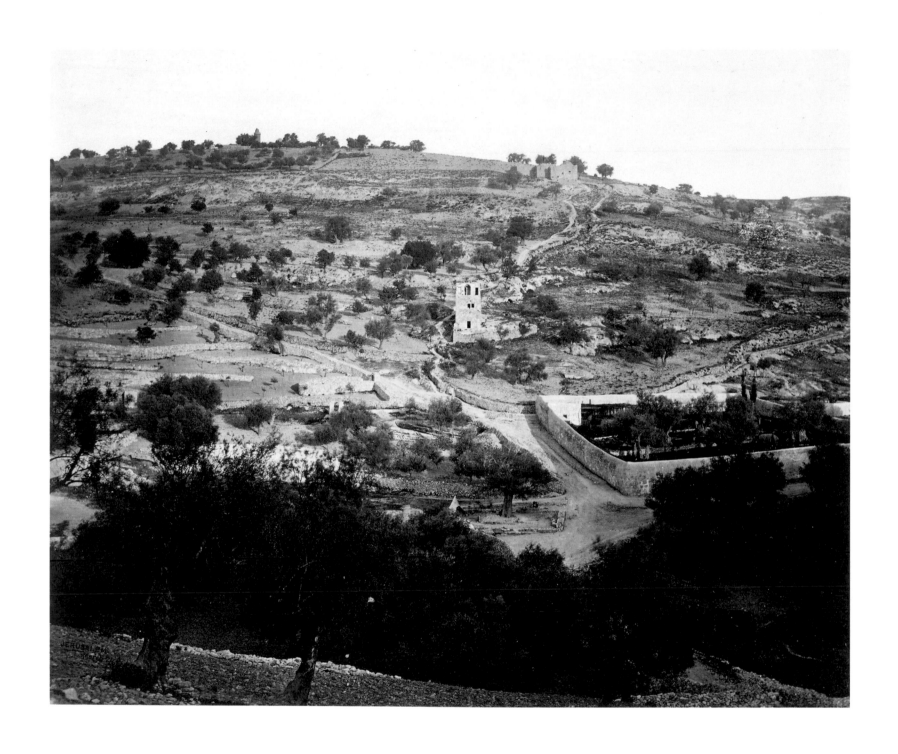

Francis Bedford
English (1816–1894)
Jerusalem, View of the Mount of Olives Showing the Garden of Gethsemane, 1862
Albumen print, 9 1/8 x 11 1/4 inches
Michael and Jane Wilson Collection

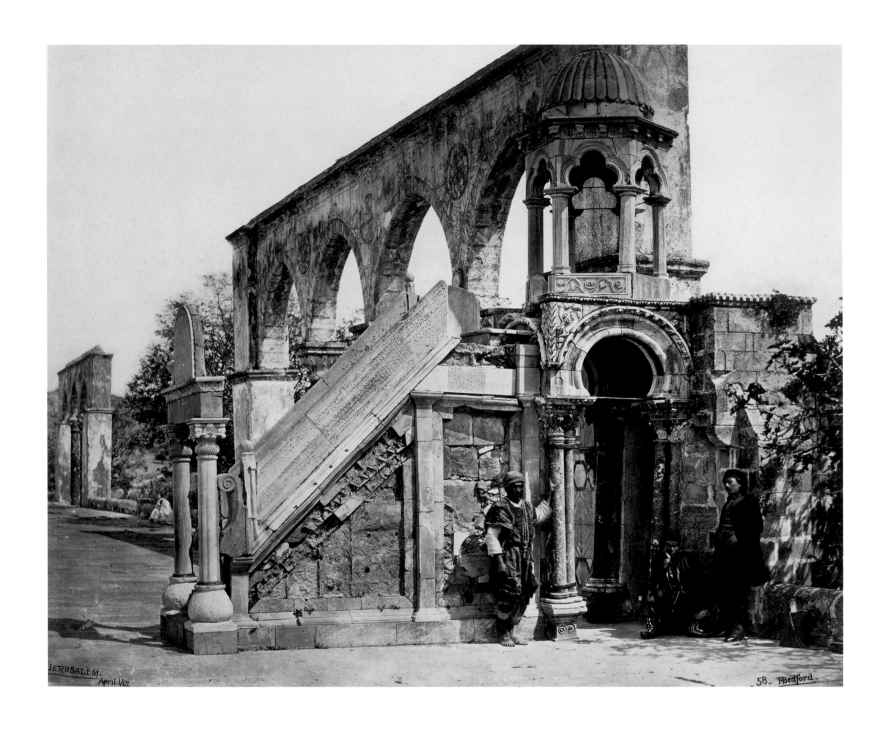

Francis Bedford
English (1816–1894)
Jerusalem, Mihrab or Pulpit in the Enclosure of the Mosque of the Dome of the Rock, 1862
Albumen print, 9 1/4 x 11 3/8 inches
Michael and Jane Wilson Collection

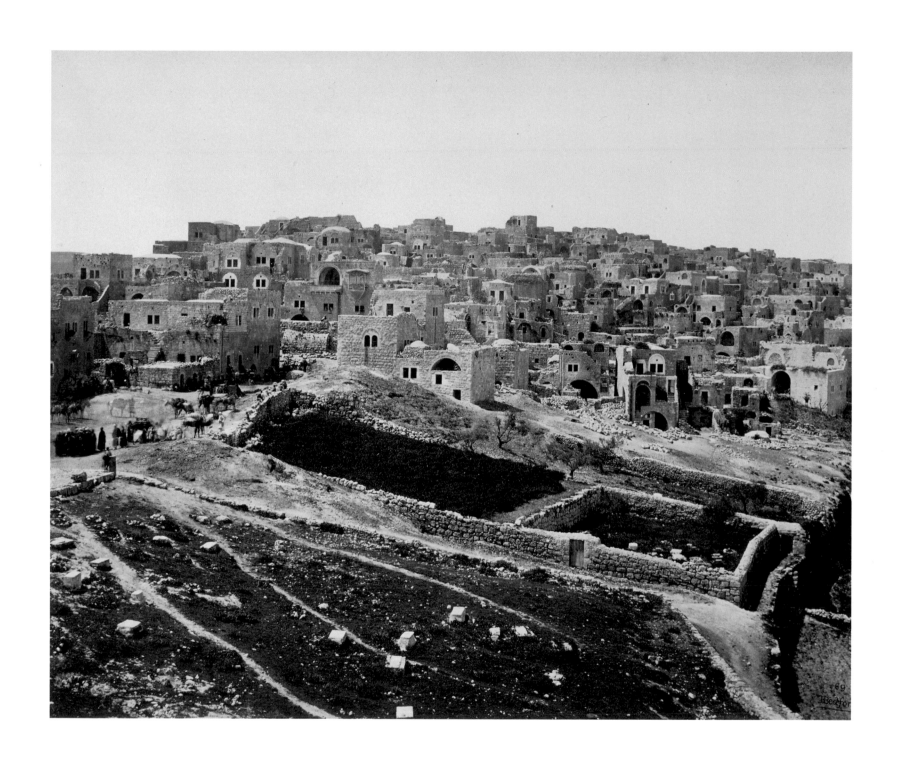

Francis Bedford
English (1816–1894)
Bethlehem, The Town from the Roof of the Church of the Nativity, 1862
Albumen print, 8 3/4 x 11 1/4 inches
Michael and Jane Wilson Collection

Francis Bedford
English (1816–1894)
The Convent and Ravine of the Kidron, 1862
Albumen print, 9 1/4 x 11 1/4 inches
Michael and Jane Wilson Collection

Felix Bonfils
French (1831–1885)
The Tomb of Rachel, c. 1870
Albumen print, 7 x 9 ¹/2 inches
Michael and Jane Wilson Collection

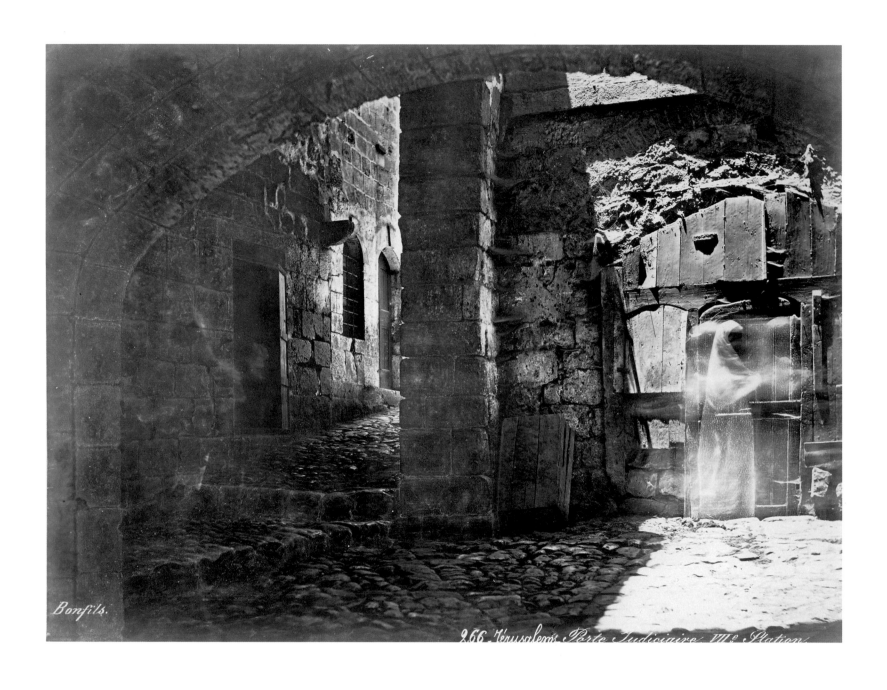

Felix Bonfils
French (1831–1885)
Gate of Justice, The Seventh Station of the Cross, c. 1870
Albumen print, 8 3/8 x 11 inches
Michael and Jane Wilson Collection

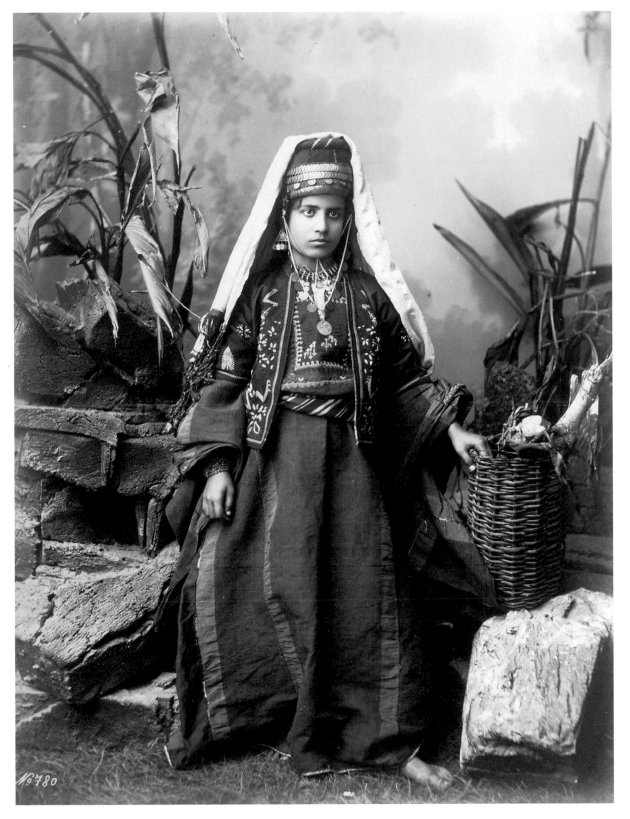

Felix Bonfils
French (1831–1885)
Bethlehem Woman, c. 1870
Albumen print, 11 x 8 1/2 inches
Michael and Jane Wilson Collection

"In the mountain of the height of Israel will I plant the cedar, and it shall bring forth boughs, and bear fruit, and be a goodly tree," Ezekiel 27.

Frank Mason Good
English (active 1860–1880s)
Cedars of Lebanon, c. 1875
Albumen print, 6 x 8 1/4 inches
Michael and Jane Wilson Collection

"And David arose and went down to the wilderness of Paran," SAMUEL 1.

Frank Mason Good
English (active 1860–1880s)
Encampment in the Wilderness of Paran, Sinai, c. 1875
From *Palestine and Syria,* 1885
Albumen print, 6 1/8 x 8 1/8 inches
Michael and Jane Wilson Collection

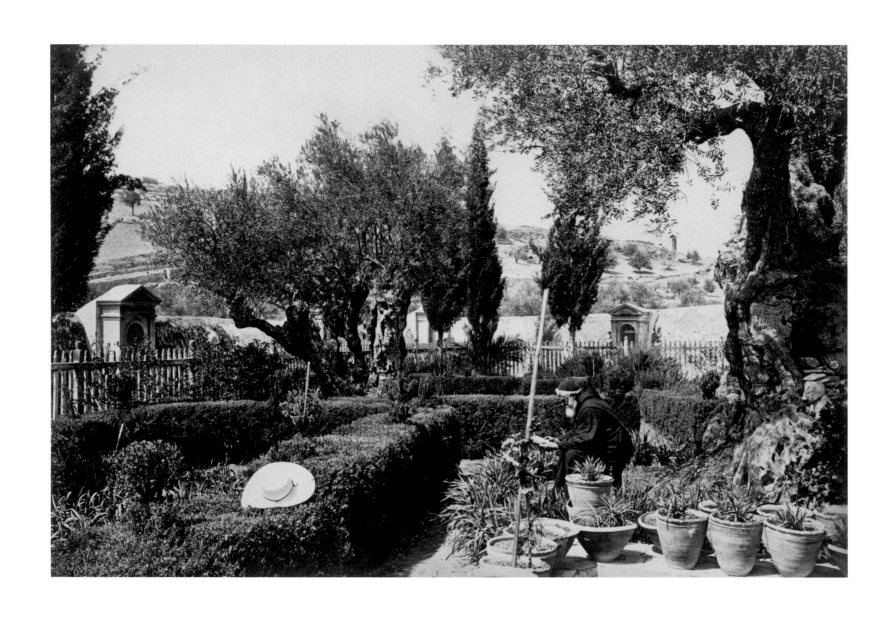

Frank Mason Good
English (active 1860–1880s)
Jerusalem, View in the Garden of Gethsemane, c. 1875
Albumen print, 5 7/8 x 8 3/4 inches
Michael and Jane Wilson Collection

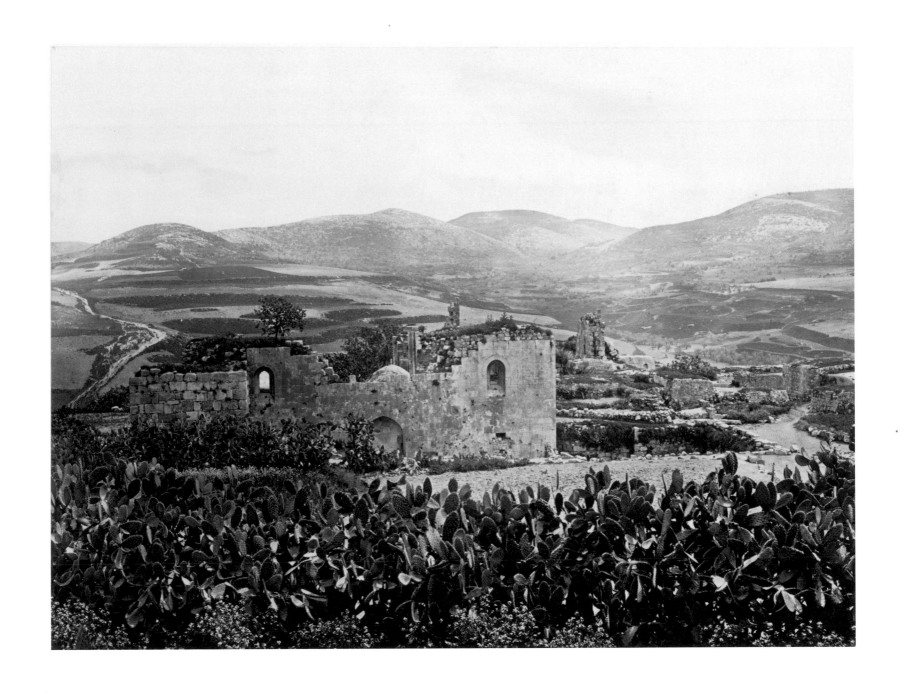

Frank Mason Good
English (active 1860–1880s)
Samaria (Sebaste), with the Ruins of the Church of Saint John, c. 1875
From *Palestine and Syria,* 1885
Albumen print, 6 $^{1}/_{4}$ x 8 $^{1}/_{4}$ inches
Michael and Jane Wilson Collection

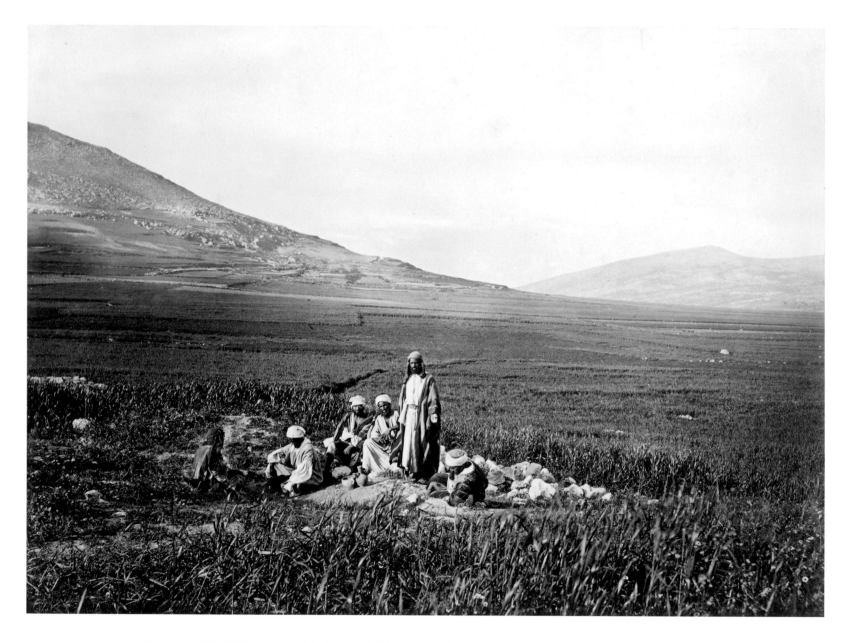

"Jesus said, 'Whosoever drinketh of this water shall thirst again, but whosoever drinketh of the water that I shall give him shall never thirst; but the water that I shall give him shall be in him a well of water, springing up into everlasting life,'" JOHN 4.

Frank Mason Good
English (active 1860–1880s)
Jacob's Well near Shechem, c. 1875
From *Palestine and Syria,* 1885
Albumen print, 6 1/8 x 8 1/4 inches
Michael and Jane Wilson Collection

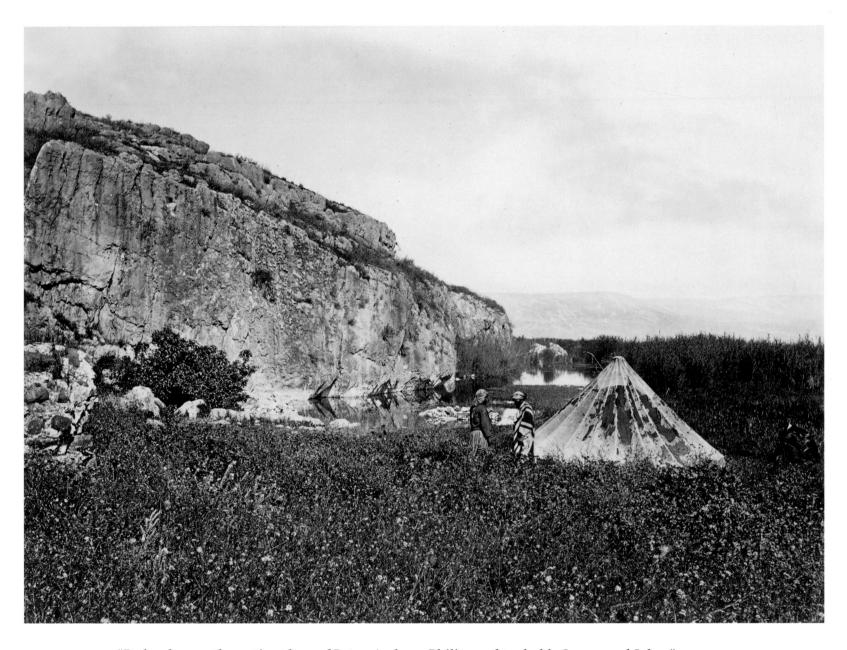

"Bethesda was the native place of Peter, Andrew, Philip, and probably James and John," JOHN 1.

"And on this beach, or that of Capernaum, they were called to follow Christ," MARK 1.

"The Doom pronounced upon Bethesda and Capernaum appears to have been wonderfully fulfilled," MATTHEW 6.

Frank Mason Good
English (active 1860–1880s)
Site of Bethesda—Sea of Galilee, c. 1875
From *Palestine and Syria,* 1885
Albumen print, 6 1/8 x 8 1/4 inches
Michael and Jane Wilson Collection

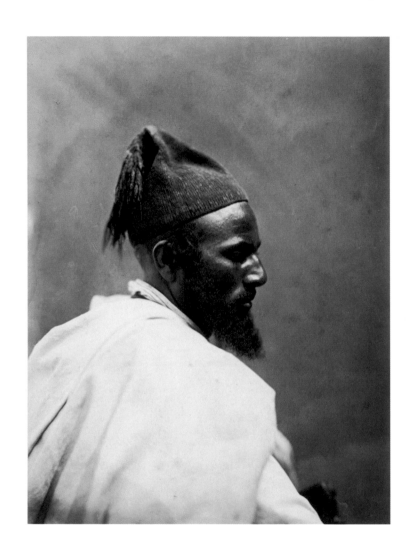

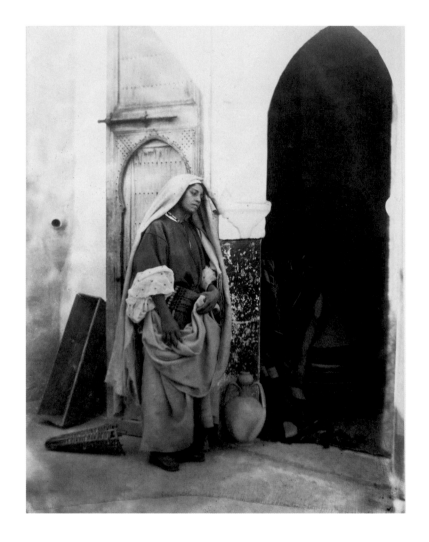

Gustave de Beaucorps
French (active 1850s)
Arab Man in Profile, 1850s
Albumen print, 8 1/4 x 6 3/8 inches
Michael and Jane Wilson Collection

Gustave de Beaucorps
French (active 1850s)
Profile of a Woman, 1850s
Albumen print, 8 1/2 x 6 1/4 inches
Michael and Jane Wilson Collection

Francis Bedford
English (1816–1894)
Portrait of Abdul Abd-el-kader, 1862
Albumen print, 8 7/8 x 7 1/2 inches
Michael and Jane Wilson Collection

Unknown
Arab Woman, 1870s
Albumen print, 9 3/8 x 7 1/2 inches
Santa Barbara Museum of Art, Museum purchase with
funds provided by Friends of Photographic Art

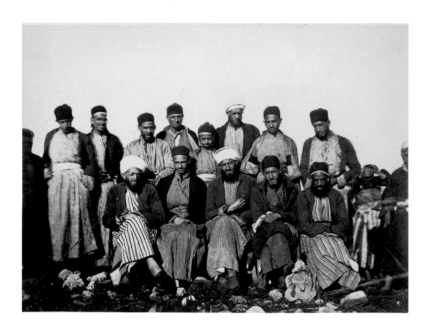

Unknown
A Group of Tribesmen, Palestine, 1860s
Albumen print, 5 7/8 x 7 7/8 inches
Michael and Jane Wilson Collection

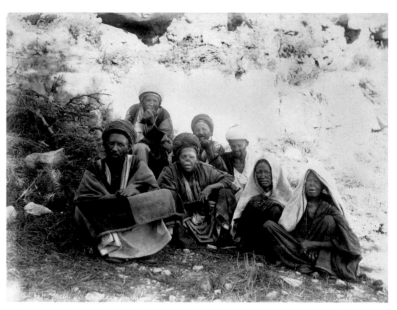

Felix Bonfils
French (1831–1885)
Group of Lepers, Jerusalem, c. 1870
Albumen print, 8 3/4 x 11 1/8 inches
Michael and Jane Wilson Collection

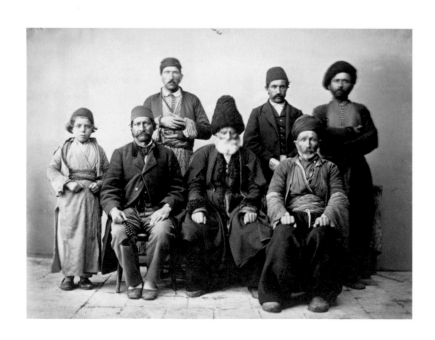

Lt. Horatio Phillips
English (active in Holy Land 1865–1870)
Armenian Pilgrims, Jerusalem, c. 1870
Albumen print, 6 1/2 x 8 1/4 inches
Michael and Jane Wilson Collection

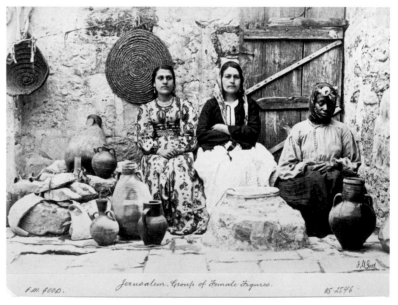

Frank Mason Good
English (active 1860–1880s)
Jerusalem, Group of Female Figures, c. 1875
Albumen print, 5 7/8 x 9 inches
Michael and Jane Wilson Collection

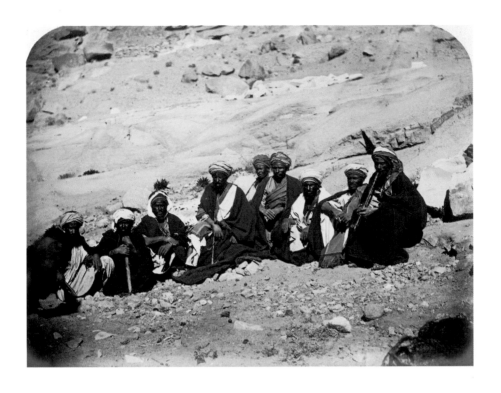

Sergeant James McDonald
English (1822–1885)
Group of Bedouin at the Convent of Saint Catherine, 1868–1869
From *Ordnance Survey of the Peninsula of Sinai,* Part III: *Photographs,* Volume 1
Albumen print, 6 $^5/8$ x 8 $^1/2$ inches
Michael and Jane Wilson Collection

Frank Mason Good
English (active 1860–1880s)
Group of Bethlehem Women and *Group of Bethlehem Men,* c. 1875
Albumen print diptych, 5 $^7/8$ x 8 $^3/8$ inches
Michael and Jane Wilson Collection

CHRONOLOGY

1291	The Crusaders suffer their final defeat in the Holy Land when Acre falls to the Mamelukes.
1517	Jerusalem and Palestine become part of the Ottoman Empire.
1775	Ottoman Turks impose a head-tax on all Jews.
1799	Napoleon marches from Egypt to Acre where he fails to capture the city.

> *"Bonaparte has caused a proclamation to be issued, in which he invites all the Jews of Asia and Africa to come and range themselves under his flags; in order to re-establish Jerusalem as of old."*
> —MONITEUR, PARIS

1831	Jerusalem captured by Muhammed Ali of Egypt.

1835

> *"There she lay, the Sea of Galilee. Less stern than Wastewater—less fair than gentle Windermere—she had still the winning ways of an English lake: she caught from the smiling heavens unceasing light and changeful phases of beauty; and with all this brightness on her face, she yet clung fondly to the dull he-looking mountain at her side. . . ."*
> —ALEXANDER KINGLAKE, EOTHEN

1836	Muhammed Ali's successor, Ibrahim Pasha, gives the Jews permission to repair their four main synagogues.

1838

> *"In the N.E. [of the city] the whole slope within the city walls is occupied by gardens, fields, and olive yards, with comparatively few houses or ruined dwellings; the whole being more the aspect of a village in the country than a quarter in a city."*
> —E. ROBINSON AND E. SMITH, BIBLICAL RESEARCHES

July 1839	The invention of a photographic process by Louis Jacques Mandé Daguerre is announced in Paris. He demonstrates it to the public in August.
December 1839	Frédéric Goupil-Fesquet makes the first daguerreotypes in Jerusalem.
1840	Jerusalem and Palestine revert to Ottoman Turkish rule.
	Joly de Lotbinière makes daguerreotypes in Jerusalem.

1842 The British traveler William H. Bartlett visits Palestine and Jerusalem. On his return to England he publishes *Walks about the City and Environs of Jerusalem.*

> *"If the traveller can forget that he is treading on the graves of a people from*
> *whom his religion has sprung, on the dust of her kings, prophets, and holy men,*
> *there is certainly no city in the world that he will sooner wish to leave than*
> *Jerusalem. Nothing can be more void of interest than her gloomy, half-ruinous*
> *streets and poverty stricken bazaars, which except at the period of pilgrimage at*
> *Easter, present no signs of life or study of character to the observer."*
> —W. H. BARTLETT

1843–44 Joseph-Philibert Girault de Prangey makes over one hundred daguerreotypes in the Holy Land.

1844 George Skein Keith takes daguerreotypes for his father Alexander Keith's book *Evidence of the Truth of the Christian Religion.*

The London Society for the Promotion of Christianity amongst the Jews sends a physician to serve their mission and the Jewish population. They establish a hospital.

> *"In Jerusalem, which is in a commercial point of view but a paltry inland*
> *Eastern town without trade or importance of any kind, sit the consuls of the*
> *five great Europeans powers, looking at one another, and it is difficult to say*
> *why and wherefore."*
> —RIDLEY HERSCHELL, ENGLISH VISITOR TO THE CITY

1847 The Franciscans build a wall around the Garden of Gethsemane.

> *"A large number of houses in Jerusalem are in dilapidated and ruinous state.*
> *Nobody seems to make repairs so long as his dwelling does not absolutely refuse*
> *him shelter and safety. If one room tumbles about his ears, he removes into*
> *another, and permits rubbish and vermin to accumulate as they will in the*
> *deserted halls."*
> —DR. JOHN KITTO, MODERN JERUSALEM

1849 The first Protestant church is consecrated in the Holy Land.

1850 Maxime Du Camp and his traveling companion, Gustave Flaubert, arrive in Jerusalem, where Du Camp makes paper negative photographs.

1850–51 Louis-Felicien Caignart de Saulcy travels to Palestine to conduct research, and returns to Paris with fragments from the Tombs of the Kings which he claims date to the time of King David.

> *"I reflected that it would be no advantage to science were we to tread again the*
> *beaten paths already traced by hundreds of tourists. Mystery and danger suf-*
> *ficed to fix my resolution, and I determined to proceed at once to Jerusalem."*
> —LOUIS-FELICIEN CAIGNART DE SAULCY

1851 *"The Jews of Jerusalem have obtained permission to assemble on this spot to lament over the destruction of their people, and to implore the restoration of the scene of their former glory, chanting in mournful melody not unmingled with a dawn of hope:*

Lord, build—Lord, build
Build Thy house speedily.
In haste! In haste! Even in our days,
Build Thy house speedily."
—W. H. BARTLETT

1852 The Sultan confirms the status of the Church of the Holy Sepulchre and other holy places as freely open to Christians.

1854 Auguste Salzmann makes archaeological photographs to support de Saulcy's position.

"Nothing equals the misery and the sufferings of the Jews at Jerusalem, inhabiting the most filthy quarter of the town, called hareth-el-yahoud, in the quarter of dirt, between the Zion and the Moriah, where their synagogues are situated—the constant object of Mussulman oppression and intolerance, insulted by the Greeks, persecuted by the Latins, and living only upon the scanty alms transmitted by their European brothers."
—KARL MARX, *NEW YORK DAILY TRIBUNE*, 15 APRIL

1854–56 Crimean War is fought between Russia and Turkey, aided by Britain and France when long-standing tensions over the protection of Orthodox Christians in the Holy Land are ignited.

1858 Francis Frith visits the region to make photographs.

"There are no roads in Palestine, but merely mule-tracks between important places–the 'beaten tracks' in which travellers have been content to follow each other from year to year, in order to 'do' Palestine."
—FRANCIS FRITH

1859–60 Louis De Clercq photographs in Jerusalem and Palestine.

"I applied myself to the study of the great and holy Jerusalem; I researched all the remarkable sites, but above all, those connected to the sublime life of Christ and his Cruel Passion. . . . I believed it useful to point out, exactly, the actual state of the Road of the Cross, with the stations that the pilgrim, with a woeful spirit, gripped with terror, but with profound faith wants to follow along the route that the Son of Man followed along his martyrdom."
—LOUIS DE CLERCQ

| 1862 | Edward, Prince of Wales, tours the area; photographer Francis Bedford accompanies the party. |

"Signally honored by the Prince's selection of him as the artist to whom so interesting and important a task should be intrusted, he was deeply anxious to justify the choice by the production of a large number of pictures worthy of the scenes he thus visited and of the reputation he had already achieved while his Royal Highness not seldom himself proposed subjects for pictures."
—W. M. THOMPSON
PREFACE TO THE COMMEMORATIVE ALBUM OF THE ROYAL TOUR

| 1863 | The French archaeologist de Saulcy returns to Jerusalem to excavate at the Tombs of the Kings. |

| 1864 | A team of Royal Engineers under the command of Captain Wilson arrives to survey Jerusalem. Sergeant McDonald makes photographs for the survey. |

| 12 May 1865 | The first organizational meeting of the Palestine Exploration Fund is held. |

Captain Warren is sent out by the PEF to conduct excavations around Jerusalem.

"We had started at 7 A.M. and expected to arrive at Jerusalem soon after noon, but we did not reach it till 8 P.M.; we were thus seventeen hours between Jaffa and Jerusalem on the track, a distance of thirty-six miles, which since the coach road has been made I have ridden over in less than four hours."
—CAPTAIN CHARLES WARREN, *UNDERGROUND JERUSALEM*

| 1866 | *"No gas, no torch, no wax lights up the streets and archways of Jerusalem by night. Half an hour after gunfire the bazaar is cleared, the shops and baths are closed, the camels stalled, the narrow ways deserted."*
—WILLIAM HEPWORTH DIXON |

| 1868 | Wilson and Palmer lead the Survey of the Peninsula of the Sinai by the Royal Engineers, photographed by Sergeant McDonald. |

France and Russia receive permission from the Sultan to finance the building of an iron dome on the Church of the Holy Sepulchre.

| 1869 | Mark Twain and a group of American tourists travel to Jerusalem. He writes *The Innocents Abroad,* based on the experience. |

"Jerusalem is mournful, and dreary, and lifeless. I would not desire to live here."
—MARK TWAIN

A Palestine Museum is opened by some members of the PEF at the Dudley Gallery in London.

The Suez Canal opens with great fanfare.

| 1871 | *"If you would really understand the Bible—which we circulate every year by the millions—you must understand also the country in which the Bible was first written."*
—WILLIAM THOMSON, ARCHBISHOP OF YORK |

1871–77	The PEF, with personnel from the Royal Engineers under the command of Conder and Kitchener, accomplish the Great Survey of Western Palestine.

1875 Prime Minister Disraeli purchases the Suez Canal for Great Britain.

> *"Mr. Disraeli has very large ideas and very lofty views of the position this country should hold."*
> —QUEEN VICTORIA

1876

> *"No one can traverse its [Via Dolorosa's] curious zig-zags and look at its 'holy places' with indifference, as it is sacred with the tears of many generations of pilgrims, who, according to their faith, strove to follow in the footsteps of the Lord. As a mere hard and dry matter of fact, however, there is no historical evidence whatever for the street was not even known until the fourteenth century."*
> —COOK'S HANDBOOK, 1876

1882 Egyptian revolt under Arabi Pasha.

 Edward Palmer killed by bandits in the Sinai.

 Revolt quelled by the British who establish a British Governor, Lord Cromer, in Egypt.

1885 Death of General Gordon at Khartoum.

1891

> *"What is to be her future? Shall the Russians rule through their Greek Church (as they are like to), or shall the Jews possess her?"*
> —THE REVEREND HUGH CALLAN
> THE STORY OF JERUSALEM, 1891

1892 Railway connects Jerusalem to Jaffa and the coast.

1914 World War I begins.

1917 General Allenby takes Jerusalem.

> *". . . From 0200 till 0700 that morning the Turks streamed through and out of the city, which echoed for the last time their shuffling tramp. On this same day 2,082 years before, another race of conquerors, equally detested, were looking their last on the city which they could not hold, and insomuch as the liberation of Jerusalem in 1917 will probably ameliorate the lot of the Jews more than any other community in Palestine, it was fitting that the flight of the Turks should have coincided with the national festival of Hanukah, which commemorates the recapture of the Temple from the heathen Seleucids by Judas Maccabaeus in 165 BC."*
> —OFFICIAL ACCOUNT, BRITISH CAPTURE OF JERUSALEM

1920 League of Nations grants the Mandate for Palestine to Great Britain.

BIOGRAPHY OF JAMES MCDONALD
(1822–1885)

Very little is known of the personal life of James McDonald—neither parents, childhood incidents, marriage, nor family. When he appears in the survey photographs, he stands smartly at attention in full uniform. And perhaps it is appropriate that the life of this noncommissioned officer is inscribed in military records. Those records reveal a distinguished career that mirrors some of the predominant themes of Victorian England—railroad building, exploration, and the rise of an educated middle class. His career culminated in his promotion to the rank of captain in the Royal Engineers, a significant accomplishment for a man who had entered the military at the age of seventeen as a sapper. One wonders though, as Captain McDonald looked back on his life, whether Queen Victoria's invitation to visit her at Osborne was the real culmination of his military life. "Her Majesty expressed a wish to see the artist who had produced so many beautiful photographs of the Holy Land." The Queen honored McDonald with a private audience, at the end of which she presented him with a personally inscribed copy of her own *Leaves from the Journal of Our Life in the Highlands.*

McDonald entered the Royal Sappers and Miners in 1839, the year in which Daguerre and William Henry Fox Talbot announced different photographic processes. In December 1840, he joined the Ordnance Survey at York. Only the vague outlines of his training can be determined, and then only by recourse to a description of training for an officer. A standardized training regime for officers in the Royal Engineers had been in place since 1833; it devoted 140 days of training to field works (trenches, barriers, bridges, etc.), 230 to surveying, 20 days to siege plans, 40 to demolition (later telegraph technology was added in this category), and 140 days to basic architecture. After 1855, optional courses in chemistry and photography were offered. As a noncommissioned member of the engineers, McDonald would have completed a basic 180-day course in surveying and then been assigned to other courses at the discretion of his superiors. After training he continued to work for the Ordnance Survey until 1845, at which time he purchased his discharge. The writer of his obituary ascribed his decision to leave the Royal Engineers to the "railway mania" that swept England at mid-century, for it was at this time that the railroads linking almost every section of England were being built. After his five years in the Royal Engineers, McDonald had the training and the experience to survey the routes for the iron highways that were changing the fabric of Victorian life. At the end of 1846, the surveys for the first rush of rail building were completed. He returned to work for the Ordnance Survey as a civilian until he rejoined the Royal Engineers in 1849. He "passed through the ranks quickly" and was promoted to sergeant in 1855. This was about the time that Colonel Sir Henry James (later Lieutenant General) championed the use of photography for reducing and reproducing maps. James appointed Sergeant McDonald to supervise both

the implementation of the process and the training of engineers in it. It must have been at this time that McDonald became an expert photographer. There is no record of his having any prior association with amateur photographic groups.

In 1864, Lieutenant Charles Wilson requested that Sergeant McDonald be assigned as the senior noncommissioned officer on the survey team Wilson was taking to Jerusalem. It is safe to assume that his request for McDonald's presence was based more on McDonald's reputation as a surveyor than on his abilities as a photographer.

For the 1868 survey of the Sinai Peninsula, Colonel Sir James turned to the team that had successfully completed the Jerusalem Survey. Captain Wilson led the team and again was paired with McDonald who had been promoted to colour sergeant since their work in Jerusalem and whom he described as "not only a skillful surveyor but also a most excellent photographer . . . hitherto in charge of the photography department." The Sinai Survey was completed in 1869. The team returned via Egypt where they had been directed by Colonel James to obtain exact measurements of the sides of the Great Pyramid and the Nilometer, the ancient stone construction by which the annual flood levels of the Nile were measured. James published a report of the work, illustrated with four of McDonald's photographs reproduced in the photozincograph process James had invented and championed for photographic reproductions of maps.

It was upon the survey team's return from the Sinai that Queen Victoria invited McDonald, now Regimental Sergeant Major McDonald, to visit her at Osborne. The royal invitation was prompted by his photographs of the Holy Land, which the Reverend George Wilson, writing in the geographical section of the survey report, described as furnishing "history with a theatre adequate to the requirements of the stupendous Drama which it records as having been enacted there."

Later that same year, McDonald was made quartermaster of the Royal Engineers's establishment at Southampton. He retired from that post in 1881 with the rank of captain, and died four years later, on 31 October 1885.

NOTES

1. Unless otherwise noted, McDonald's career and quotations regarding that career are taken from the Obituary Notice in *Royal Engineers Journal,* vol. 15, 274, Royal Engineers Institute, London, 1885. Assistant Librarian Mrs. M. Magnuson and the staff of the Archives and Library of the Royal Engineers at Brompton Barracks, Chatham, generously assisted my search for McDonald's records.

2. McDonald was intimately associated with the photography program from its inception.

3. Whitworth Porter, *History of the Corps of the Royal Engineers,* vol. 2 (London: Longmans, Green and Co., 1889), 183.

4. There is a discrepancy in the records here. McDonald's obituary specifically states that James involved McDonald from the very beginning in his photographic projects. John Falconer, in his carefully researched article, "Photography and the Royal Engineers," mentions neither McDonald nor James in the earliest applications of photography by the Royal Engineers. *The Photographic Collector,* vol. 2, no. 3, Autumn 1981, 33-64.

5. Wilson, "Members of the Survey," in *The Ordnance Survey of the Sinai Peninsula,* Appendix III (London, 1869), n.p.

6. The description, a particularly telling example of the mindset I refer to as geopiety, is taken from the Reverend George Wilson's "Descriptive Geography," the first chapter in *The Ordnance Survey of the Sinai Peninsula,* 6.

SELECTED BIBLIOGRAPHY

Albright, William Foxwell. *The Archaeology of Palestine and the Bible.* New York, London and Edinburgh: Fleming H. Revell, 1932.

Bartram, Michael. *The Pre-Raphaelite Camera.* Boston: New York Graphic Society, 1985.

Benvenisti, Meron. *City of Stone: The Hidden History of Jerusalem.* Berkeley: University of California Press, 1996.

Davis, John. *The Landscape of Belief: Encountering the Holy Land in Nineteenth-Century American Art and Culture.* Princeton: Princeton University Press, 1996.

Falconer, John. "Photography and the Royal Engineers." *The Photographic Collector* 2, no. 3 (Autumn 1981): 33–64.

Gavin, Carney E. S. *The Image of the East: Nineteenth-Century Near Eastern Photographs by Bonfils.* Chicago: University of Chicago Press, 1982.

Gilbert, Martin. *Jerusalem: Illustrated History Atlas.* 3d ed. London: Vallentine Mitchell, 1994.

Haworth-Booth, Mark. *The Golden Age of British Photography 1839–1900.* New York: Aperture, 1984.

Howe, Kathleen Stewart. *Excursions Along the Nile: The Photographic Discovery of Ancient Egypt.* Santa Barbara, California: Santa Barbara Museum of Art, 1993.

Jammes, André, and Eugenia Parry Janis. *The Art of French Calotype, with a Critical Dictionary of Photographers, 1845–1870.* Princeton: Princeton University Press, 1983.

Nir, Yeshayahu. *The Bible and the Image: The History of Photography in the Holy Land, 1839–1899.* Philadelphia: University of Pennsylvania Press, 1985.

Onne, Eyal. *The Photographic Heritage of the Holy Land, 1839–1914.* Manchester: Manchester Polytechnic, 1980.

Pare, Richard. *Photography and Architecture: 1839–1939.* Montreal: Canadian Centre for Architecture, 1982.

Perez, Nissan. *Focus East: Early Photography in the Near East (1839–1885).* New York: Harry N. Abrams, 1988.

Rosovsky, Nitza, ed. *City of the Great King: Jerusalem from David to the Present.* Cambridge, Mass., and London: Harvard University Press, 1996

Ruby, Robert. *Jericho: Dreams, Ruins, Phantoms.* New York: Henry Holt and Company, 1995.

Schiller, Ely. *The First Photographs of the Holy Land.* Jerusalem: Ariel Press, 1979.

Shepherd, Naomi. *The Zealous Intruders: From Napoleon to the Dawn of Zionism—The Explorers, Archaeologists, Artists, Tourists, Pilgrims and Visionaries Who Opened Palestine to the West.* San Francisco: Harper and Row, 1987.

Silberman, Neil Asher. *Digging for God and Country: Exploration, Archeology, and the Secret Struggle for the Holy Land, 1799–1917.* New York: Alfred A. Knopf, 1982.

Sillitoe, Alan. *Leading the Blind: A Century of Guide Book Travel, 1815–1914.* London: Macmillan, 1995.

Tibawi, A. L. *British Interests in Palestine 1800–1901.* London: Oxford University Press, 1961.

Tuchman, Barbara W. *Bible and Sword: England and Palestine from the Bronze Age to Balfour.* 1956. Reprint. New York: Ballantine Books, 1984.

Vaczek, Louis, and Gail Buckland. *Travelers in Ancient Lands, Portrait of the Middle East, 1839–1919.* Boston: New York Graphic Society, 1981.

Van Haaften, Julia. *Egypt and the Holy Land in Historic Photographs—77 Views by Francis Frith.* New York: Dover, 1980.

Warner, Malcolm. "The Question of Faith: Orientalism, Christianity and Islam." In *The Orientalists: Delacroix to Matisse, European Painters in North Africa and the Near East,* edited by MaryAnne Stevens, 32–39. London: Royal Academy of Arts, 1984.

INDEX

ABOUT THE AUTHORS

KATHLEEN STEWART HOWE received her Ph.D. in the history of photography from the University of New Mexico. She has published and lectured on expeditionary photography in the nineteenth century, on the connections between printmaking and photography, and on contemporary photographic practice. Author of *Felix Teynard: Calotypes of Egypt, A Catalogue Raisonné* (Kraus, Hershkowitz, and Weston, 1992) and *Excursions Along the Nile: The Photographic Discovery of Ancient Egypt* (Santa Barbara Museum of Art, 1993), Dr. Howe is curator of prints and photographs at the University of New Mexico Art Museum.

NITZA ROSOVSKY was born and grew up in Jerusalem where she attended Hebrew University. Author of *Jerusalemwalks* (Henry Holt, 1992, 2nd edition), co-author of *The Museums of Israel* (Harry N. Abrams, 1989), and editor of *City of the Great King: Jerusalem from David to the Present* (Harvard University Press, 1996), Ms. Rosovsky has organized numerous exhibitions of photographs from the Holy Land and written extensively about the history of photography.